PICO RIVERA
IMAGES of America

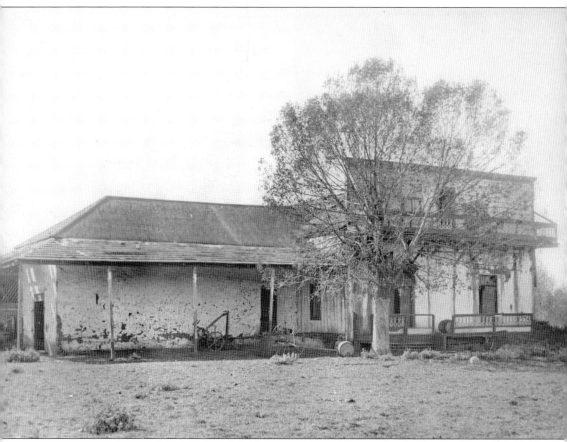

Pio Pico Mansion. The mansion of the last Mexican governor of California was built in 1852. This property has gone through several changes throughout the years. Many of these changes were largely destroyed by floods in the late 19th century. The mansion is just east of the San Gabriel River in the city of Whittier. Pico Rivera, Pico Park, and Pio Pico Elementary School were all named after the former governor, who passed away on September 11, 1894. (Courtesy of the Pico Rivera History and Heritage Society.)

On the Cover: The Rivera Band, standing in front of the Rivera Hotel around the 1900s, provided lively entertainment at community affairs. (Courtesy of the Pico Rivera History and Heritage Society.)

Pico Rivera History and Heritage Society

Copyright © 2008 by the Pico Rivera History and Heritage Society
ISBN 978-0-7385-5599-7

Published by Arcadia Publishing
Charleston SC, Chicago IL, Portsmouth NH, San Francisco CA

Printed in the United States of America

Library of Congress Catalog Card Number: 2007934164

For all general information contact Arcadia Publishing at:
Telephone 843-853-2070
Fax 843-853-0044
E-mail sales@arcadiapublishing.com
For customer service and orders:
Toll-Free 1-888-313-2665

Visit us on the Internet at www.arcadiapublishing.com

This book is dedicated to those who have used their time and energy throughout the years to preserve the wonderful history of the city of Pico Rivera.

CONTENTS

Acknowledgments		6
Introduction		7
1.	Glimpses of Early Days	9
2.	A Tale of Two Cities	63
3.	A New Beginning	85

ACKNOWLEDGMENTS

We are grateful for the input, writing, correcting, editing, researching, and scanning of the following individuals: Raul A. Riesgo, Nora Morales, Beverly Walker, Connie Alonzo, Susana C. Lozano, Miguel Galindo, Marisol C. Galindo, and Silvia Galindo.

A special thank-you goes to Oscar Castillo for scanning most of the images used in this book.

We would like to acknowledge the following groups for sharing photographs and information: the City of Pico Rivera, Rio Hondo College—Student and Community Services, the Pico Rivera History and Heritage Society, and El Rancho Unified School District.

A special thank-you goes to the following individuals for sharing their valued photographs: Connie Alonzo, Rudy Casas, Frances Drake (Sidwell family), Anita Cowan, Celia T. Galindo, Josie Gallardo, Edward Hertel, Jeanne Hertel, Wesley Kruse, Susana C. Lozano, Nora Morales, and Sylvia Rodriguez.

These photographs are now part of the Pico Rivera History and Heritage Society collection, which was the primary source for the images used in this book. The Pico Rivera History and Heritage Society formed in 1971 when many residents desired a facility for the preservation and documentation of the colorful history of this city. This group, made up of longtime residents, currently maintains the Pico Rivera Historical Museum on Washington Boulevard. Those interested in the study and continued preservation of our wonderful history are encouraged to visit the museum or participate in any one of the many activities hosted by the society.

Introduction

Pico Rivera has as rich a heritage as any other city in California. When the metropolitan era of Greater Los Angeles sprawled eastward in the 1950s, the country towns of Pico and Rivera met the challenge by joining to form Pico Rivera, incorporating in early 1958. However, the history extends back much farther.

Most of present-day Pico Rivera lies in the original Rancho Paso de Bartolo Viejo, a land grant given by Mexican governor José Figueroa to Juan Crispin Perez in 1835. Pico Rivera also included a portion of the Santa Gertrude grant, which was the part of the Nieto ranch inherited by the widow of Antonio Nieto, Dona Jose Cota. In 1843, Cota sold her portion to Lemuel (Samuel) Carpenter, who lost it by foreclosure less than 20 years later.

Juan Crispin Perez and his heirs sold part of the Rancho Paso de Bartolo Viejo to Gov. Pio Pico, Bernardo Guirado the elder, and Joaquina Sepulveda. The major portion of this land became the Rancho de Bartolo, or the beloved "El Ranchito" of Pio Pico, last Mexican governor of California. He purchased it between August 1850 and March 1852. By then, the former governor had built his home upon the ranch and was living there on the Whittier side of the San Gabriel River. Much of his ranch encompassed lands that became part of Pico Rivera. He began selling parcels to settlers in about 1865.

Some of the early pioneers and families in the Pico Rivera area were James W. Cate, James Stewart, E. R. Wylie, Edgar Coffman, Charles Coffman, Frank Coffman, Joseph A. Burke, Tom Gooch, William Moss, Montgomery Tyler, Samuel Thompson, Seaborn Reynolds, Harrison Montgomery, J. W. McGaugh, James Shugg, W. P. Story, James H. Davis, James F. Isbell, W. P. McDonald, Louis Bequette, Steve Smith, James Standlee, William Sidwell, Daniel White, and James Durfee. Names of other families who settled in the area before 1900 included Spencer, Witherow, Germain, Dunlap, Triggs, Broadbent, and Boyce.

The Rivera area was first called Maizeland because of the fine corn and maize grown in the fertile valley soil. The town of Rivera was plotted in 1886 upon the arrival of the Santa Fe Railroad. One of the chief promoters of the town of Rivera was Louis L. Bequette, a native of Wisconsin. Bequette, the Burkes, and other pioneers were instrumental in bringing the railroad to Rivera. They promoted the selling of town lots in 1887.

The town of Pico was not formed until many years after the founding of Rivera, although the Salt Lake Railroad, later the Union Pacific, had opened a Pico station in 1902.

E. P. Reed started the Pico development on a larger scale in early 1923 and named the town. He first subdivided the 10-acre walnut orchard of Phil Maurer and Oswald White at the northwest corner of Durfee Road and Whittier Boulevard. His partner was L. D. Thomason. They sold the site for the development of the Charles Thomas business block on Whittier Boulevard a block west of Durfee Road. Reed's firm eventually divided 97 acres. John Deland and V. Lindsay subdivided 20 acres on the south side of the boulevard.

The first residents of the town of Pico were the Reed and Thomason families, Garf Sykes, the Penningtons, the Johnsons, Grace Cravens and family, the Summers family, and O. J. Abrams

and Henry Drake, along with their families. Pioneer ranchers who joined the Pico development were C. L. Edmonston, Tom Gooch, Percy Wile, Ray Reese, Bill Howell, and Victor Deihl.

Before 1947, Pico and Rivera were unincorporated country towns separated by orange, walnut, and avocado groves. The population of Pico was concentrated near Whittier Boulevard. South of Pico was the older town of Rivera, which had grown up along the railroad line and along the central district on Serapis Avenue and Bermudez Street.

Between 1950 and 1960, the population of the area to become Pico Rivera more than doubled. Residents of Pico and Rivera became aware that the future held some definite challenges. Neighboring incorporated towns were looking for annexations. The Pico Chamber of Commerce and the Rivera Chamber of Commerce together explored the possibilities. Before the end of 1956, leaders of both chambers recommended merging the towns into an incorporated city. Many groups in both towns were opposed to the idea.

After an incorporation petition was circulated in 1957, the county supervisors set January 7, 1958, as the date for the vote on the incorporation of Pico and Rivera. A hotly contested campaign ensued. The name Pico Rivera was chosen, winning out over "Serra City." Fifty-six percent of the voters favored incorporation, endorsed the Pico Rivera name, and approved a council-manager form of government. On January 29, 1958, Pico Rivera officially became Los Angeles County's 61st city with an area of 7.6 square miles, a population of 52,113, and an assessed valuation estimated at $52 million.

The city's first councilmen were Mayor Orlyn Culp, John W. Davis, Ruth Benell, Louis R. Diaz, and James Patronite. Others who were to serve prominently on the council in the ensuing years were Lloyd Manning, Rex Sturdevant, William J. Loehr, Anthony M. Sanchez, Frank Terrazas, James Matkins, Gil De La Rosa, John G. Chavez, and Garth Gardner.

The community has continued to grow over the years, and currently, more than 66,000 residents call Pico Rivera home. The city has numerous parks, a municipal golf course, a sports arena, and a very successful sports and recreation program.

Many recognizable and some famous personalities have called Pico Rivera their home. A partial list of prominent people from Pico Rivera includes the following: Dionicio Morales (founder of the Mexican American Opportunity Foundation); Gloria Molina of the Los Angeles County Board of Supervisors; actresses Lupe Ontiveros and Alma Martinez; Jeanette Jurado, the lead singer of Expose; author John D. Fitzgerald; National Football League players Richard Camarillo (punter with the New England Patriots, Phoenix Cardinals, and other teams), Bill Nelsen (quarterback, Pittsburgh Steelers and Cleveland Browns), Bill Bain (offensive lineman, Los Angeles Rams and others), Scott Tercero (offensive guard, St. Louis Rams), Mark Bailey (running back, Kansas City Chiefs), and Jim Arellanes (quarterback and 1998 World Bowl Most Valuable Player); Major League Baseball players Sam "Wahoo" Crawford (a Baseball Hall of Famer, mostly for the Detroit Tigers), former St. Louis Cardinals players Rube Ellis, Jack Bliss, Andy Rincon, and Randy Flores, former Oakland A's players Mickey Klutts, Mike Gallego, and Ron Flores, Tom Egan (California Angels), Scott Reid (Philadelphia Phillies), and Larry Anderson (Milwaukee Brewers).

The local high school, El Rancho, has also received notoriety for its football program. During the 1960s, the program was engineered by the legendary coach Ernie Johnson. During that decade, the program won more games than any other high school in the state of California. In addition, in 1966, the program was named the no. 1 football program in the nation after finishing with a 13-0 record.

Many other notable achievements by its residents may be cited; however, space and time are limited, and such information can be reserved for a more exhaustive study.

One
GLIMPSES OF EARLY DAYS

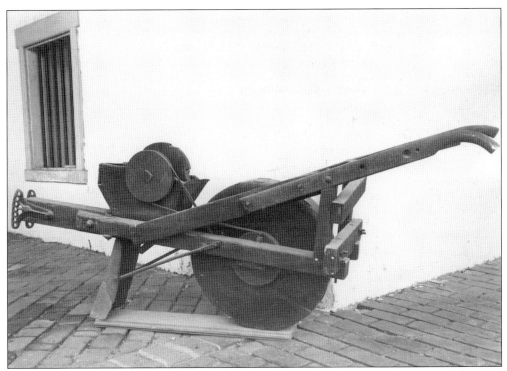

CALIFORNIA'S FIRST CORN PLANTER. This is a picture of the first corn planter used in California. It was used on Don Pio Pico's land. This corn planter would later be purchased by James W. Cate and continued to be used in present-day Pico Rivera until more modern machinery was introduced.

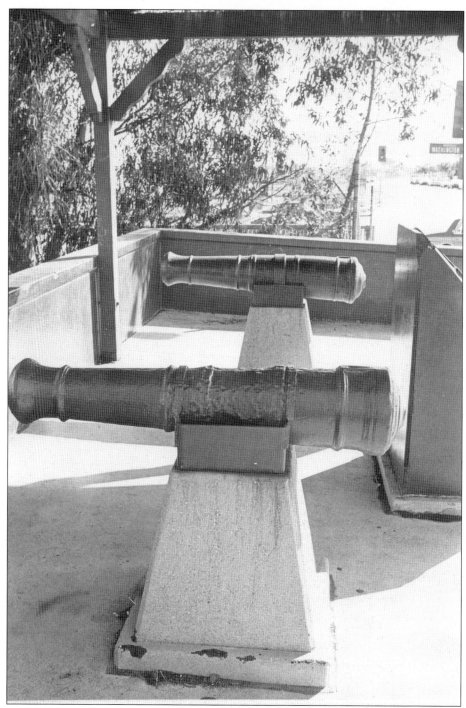

BATTLE OF SAN GABRIEL. This battle was fought in 1846 between Californians and Americans in present-day Pico Rivera. Californian forces under the command of Gen. Andres Pico, a brother of Gov. Pio Pico, were unsuccessful in their attempt to stop American forces from crossing the San Gabriel River and reaching Los Angeles. These commemorative cannons are placed just west of the Rio Hondo on the outskirts of Pico Rivera.

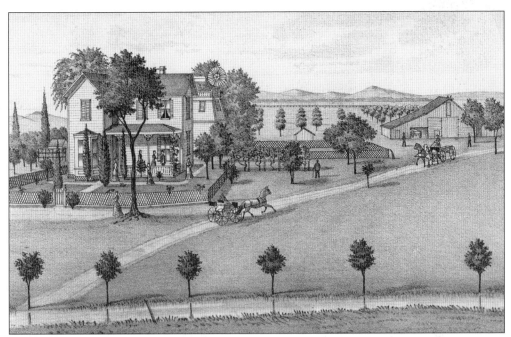

H. L. Montgomery Home. Located on 140 acres in Rivera, the Montgomery property was purchased from Pio Pico in 1868. H. L. Montgomery was one of the first to venture into the English walnut industry and to serve as the director of the Los Nietos and Ranchito Walnut Growers Association.

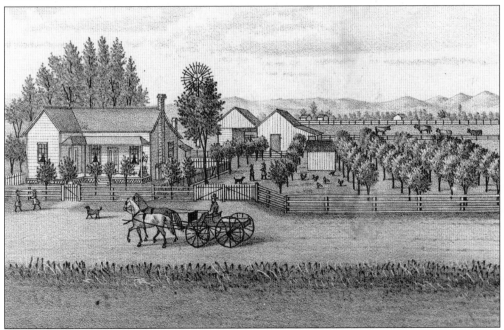

Thomas L. Gooch Ranch. Ninety-six acres in Rivera, the Gooch Ranch was devoted to walnuts and oranges. Gooch served with the Confederate forces during the Civil War. After the war, he farmed in Mississippi and Arkansas until 1870, when he arrived in California. His home would serve as the first Pico Rivera City Hall.

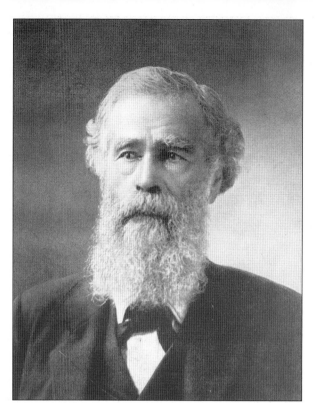

JOSEPH HARTLEY BURKE. Burke was one of two main promoters who eventually turned 50 acres of the Barton Ranch into town lots. Burke and J. F. Isbell reached an agreement on October 29, 1887, establishing the township of Rivera.

OSBURN BURKE. Burke was born in Gallatin (present-day Downey) in 1867. In 1892, he married Mary Simonson. During his 93 years, he was extremely active in community affairs. In recognition of his civic contributions, his name has been perpetuated in the Osburn Burke Middle School.

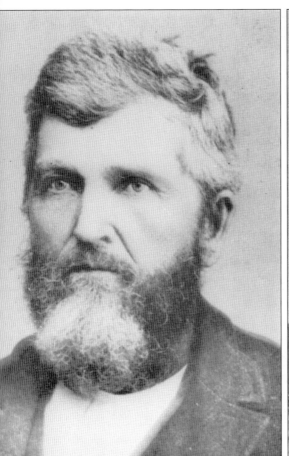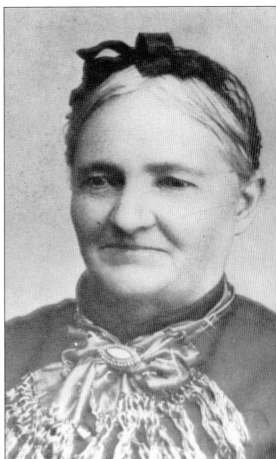

OLIVER P. AND NANCY GRAHAM PASSONS. Oliver was born on July 4, 1824, in Tennessee. In 1849, he started for the California gold fields via Mexico. While en route, he was captured by Native Americans but fortunately was released. He would later reach California by walking from Yuma, Arizona. Passons, a carpenter by trade, married Nancy Graham. In 1855, he purchased 100 acres, the first land sold in the Pico Rivera area. He also built the first frame house in this area. Eventually, Passons became a walnut grower. He died on February 25, 1895.

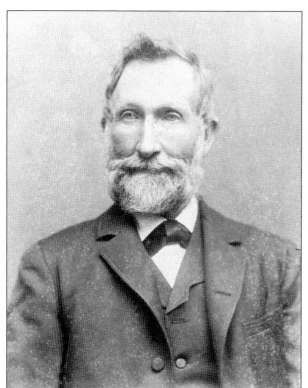

JAMES W. CATE. James Cate purchased 150 acres from Pio Pico in 1865. The purchased land was located north of Beverly Boulevard.

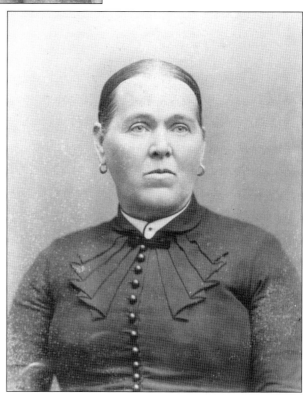

ELIZA HENDERSON CATE. Eliza Henderson arrived in Ranchito with her family in 1864. Her husband, James Cate, was a leading citizen in the Ranchito district, serving many years as the community constable.

MARY E. COFFMAN. Originally from Virginia, Mary married Charles Coffman in 1859 and eventually moved to the Ranchito area in 1869.

CHARLES COFFMAN. Coffman was involved with the freight business. In 1868, he moved to the Los Angeles area, then one year later to Ranchito. Charles passed away on October 11, 1898.

BELLE SIDWELL. Belle was married to William L. Sidwell and came to the Ranchito district in 1880. They had three children: Estella, Lester, and Chester. Belle later owned property near Whittier Boulevard and Durfee Road. She operated the Ranchito Post Office and Store.

ESTELLA SIDWELL. Estella is the daughter of William and Belle Sidwell. She married Henry Judson. Estella and her brother Lester operated the Wildwood Trailer Park on Whittier Boulevard, starting it as a campground.

JOHN L. RUSSELL. Russell lived in a modest redwood home along with his wife, Linnie, and children, Imogene and Martha. Russell spent much of his lifetime building houses in the community.

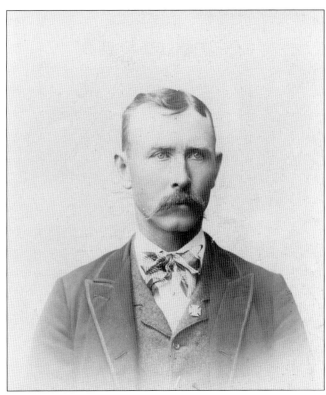

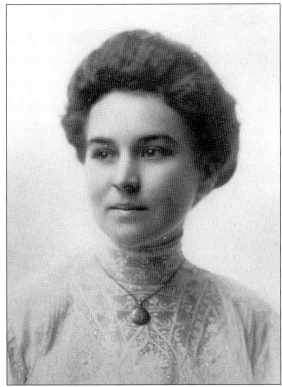

MARY E. MELLER. Raised in the Pico Rivera area, Meller's family's ranch was located at the corner of Passons Boulevard and Dunlap Crossing Road. She married Addis L. Meller. For 27 years, Mary taught in the Ranchito School District. In 1955, the Mary E. Meller Junior High School, which was later converted to an elementary school, was named in her honor.

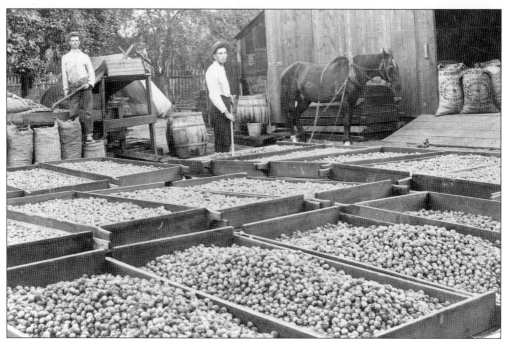

WALNUT HARVEST, 1905. E. W. Reider (right) is pictured on a busy day during the walnut harvest.

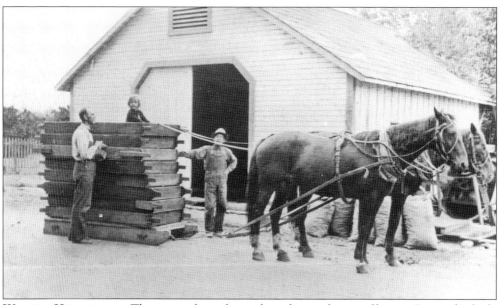

WALNUT HARVESTING. This particular task was done during the era of horses. Pictured is little Clifford with the reins, while his father, C. L. Edmonston (left), looks on. The wooden instrument pictured was used in the harvesting of walnuts.

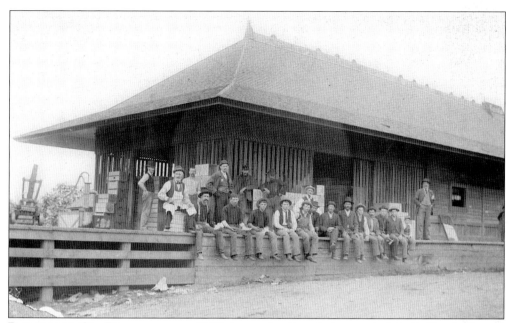

PART OF THE OLD DEPOT, AROUND 1907. Located at Serapis Avenue (originally Topeka Street) and the northwest corner of the Santa Fe Railroad tracks, the old depot included a freight station with a passenger station located across the street. A water pump located on the platform of the depot indicates the water table in the area was no more than 15 feet at that time.

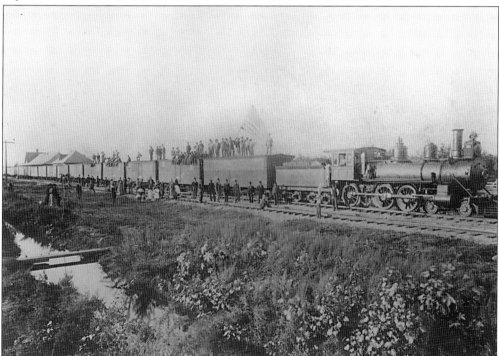

TRAINLOAD OF WALNUTS, 1880S. The English walnut was introduced in 1875. It soon proved to be a lucrative crop. The first trainload of walnuts ever shipped from a California depot was from Rivera.

SNYDER FAMILY. In 1906, William Jacob Snyder (left) and Sadie Stull Snyder purchased this property from T. B. Passons. Snyder, a railroad section foreman in Colorado, had moved his family to Pico, where he became section foreman on the San Pedro, Los Angeles, and Salt Lake Railroad. This property was located at what is today Beverly and Rosemead Boulevards.

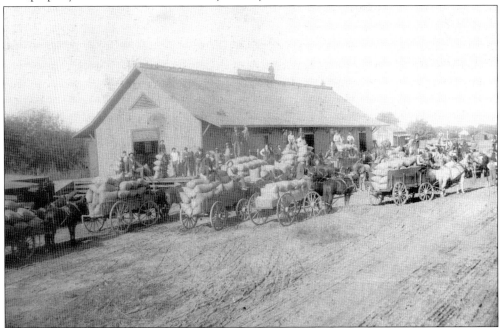

RIVERA FREIGHT HOUSE, 1880s. A typical scene depicts walnut harvest time, when trainloads of walnuts were shipped from the Rivera Freight House.

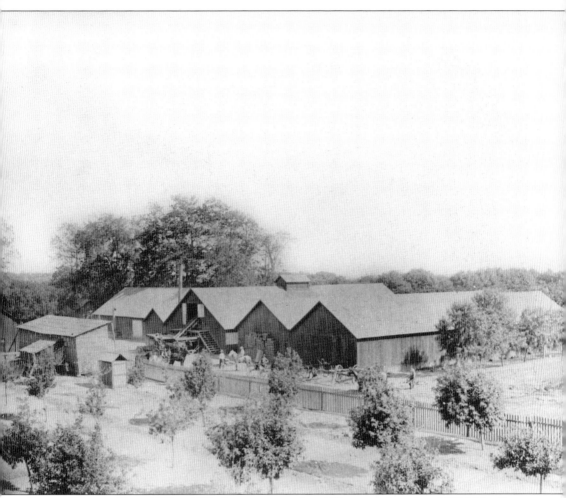

BURKE WINERY. From 1887 to 1892, the winery employed 50 men and produced 250,000 gallons of wine a year. Shipments of wine went to Europe, where it was blended and returned to the United States as imported wine.

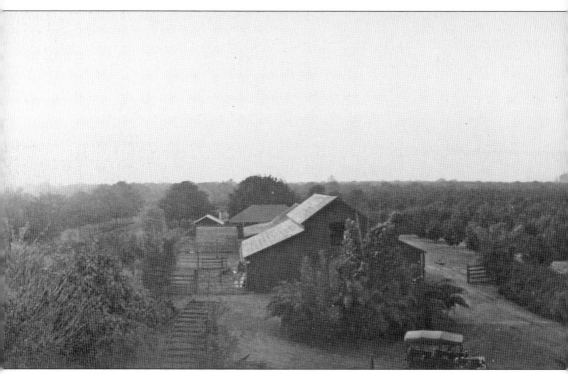

MAULSBY-EDMONSTON RANCH. This view shows orange groves on the Maulsby-Edmonston Ranch located in Rivera. At first, the planting of oranges was thought to be a serious mistake.

However, in time, the orange groves became such a lucrative and stable crop for the area that they soon replaced walnuts as the principal crop of Rivera.

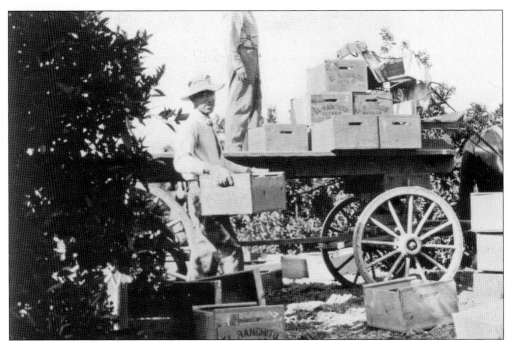

FARMING ON THE MAULSBY-EDMONSTON RANCH. Forty acres were first devoted to walnuts, then to oranges. Shortly after the dawn of the 20th century, the walnut industry declined because of the dropping of the water table, the age of trees, new pests, and disease.

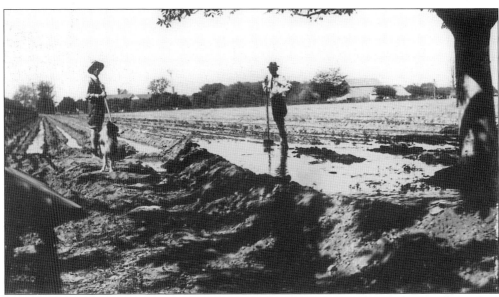

MAULSBY AND EDMONSTON. Maulsby (left) and Edmonston (right) are involved in channeling water into prepared rows. This water scene pictures the era preceding World War II. Prior to ranches being swallowed up into subdivisions, water was indispensable to growing crops.

SPENCER FAMILY. The Spencers owned a large ranch located on Passons Boulevard. Mr. and Mrs. Spencer had one son, Howard Spencer.

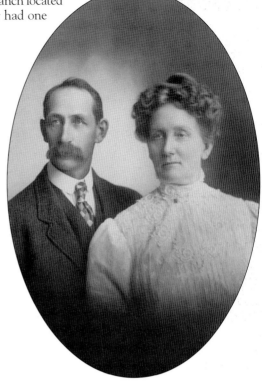

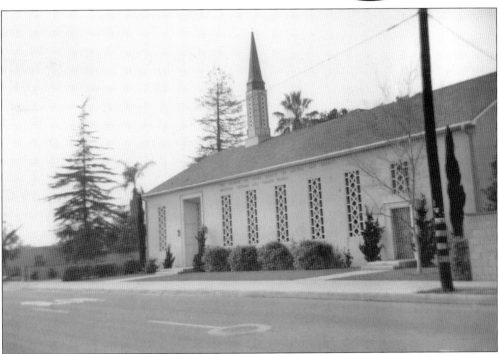

CHURCH OF JESUS CHRIST OF LATTER-DAY SAINTS. This Morman church, built in the 1950s, is today still located on Passons Boulevard.

HOWARD SPENCER. The only son born to the Spencers, Howard married late in life to a woman associated with the Church of Jesus Christ of Latter-Day Saints. The church is located on the former Spencer property.

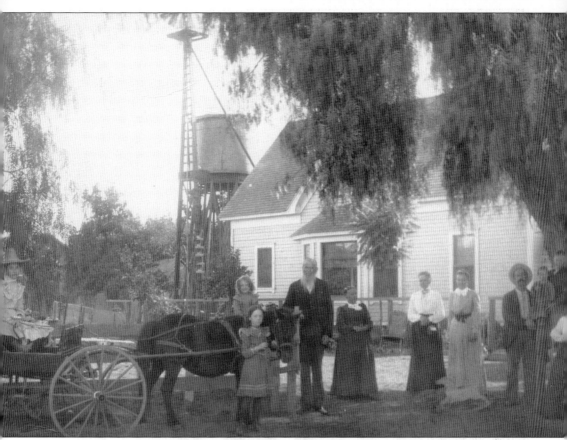

WITHEROW FAMILY. Enjoying a Sunday gathering in 1903 is the Witherow family. Those identified in the picture are Louise Witherow, holding the reins; Daniel White (with beard) and his wife, Isa, the short lady with the white collar; William Witherow, wearing a straw hat and holding his son Sydney; William's son Carl at Sydney's side; Linda Witherow, wife of William, standing in the light-colored dress; and Alta Taylor, the young girl on the far left. Others in the photograph are unidentified.

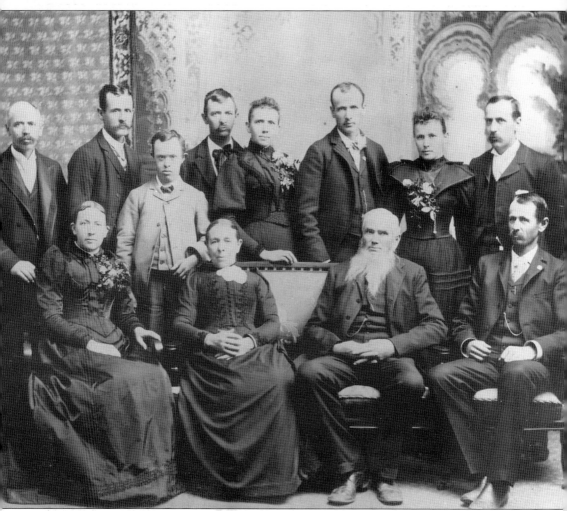

White Family. The Whites came from Canada to the area in 1883. Seen here are Walter White and his wife, Emily White, with their children. From boyhood, Walter White was familiar with agricultural pursuits and would go on to become a pioneer in the walnut growing industry in the Ranchito district.

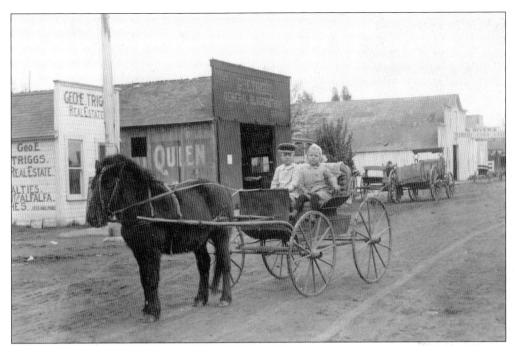

WILMA LUCILLE SIDWELL. Pictured on the right is Wilma Lucille Sidwell, the mother of Frances Drake, who is a member of the Pico Rivera History and Heritage Society. Frances Drake's two sons, Ron and Randy, played collegiate football at the University of Southern California and Long Beach State, respectively, in the late 1960s and early 1970s.

C. L. EDMONSTON. President of the Pico National Bank, Edmonston was also president of the Rivera Construction Company, which built the Rivera Ranchito Packing House. He was also on the board of the California Fruit Growers Exchange. The family members included C. L.'s wife, Lulu Maulsby Edmonston, and their children, Norman, Barbara, and Clifford.

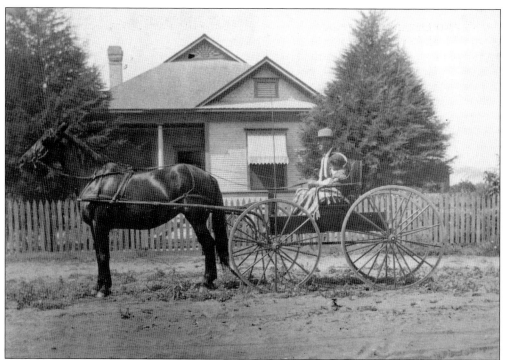

SHADE FAMILY. This family owned a 60-acre farm that bordered old Rivera. The Shade Ranch would later have one of the last orange groves in the area. Also known as Jack, E. B. Shade married Ruth Reider in 1918. Jack was the son of John A. and Eulalia Burke Shade, and he appears here with his father seated in the buggy. The home in the background was the original Shade home, built in 1895.

FRANK AND ELIZABETH COFFMAN FAMILY. Frank Coffman was born in 1861 and moved with his family to Ranchito at age nine. He would eventually acquire 105 acres of walnuts in the area. Pictured from left to right are (first row) Virginia; (second row, seated on laps) Lois and Louise; (third row) Frank, Grace, and Elizabeth; (fourth row) Maryen, Marshall, and Frances. This family portrait was taken on June 16, 1916.

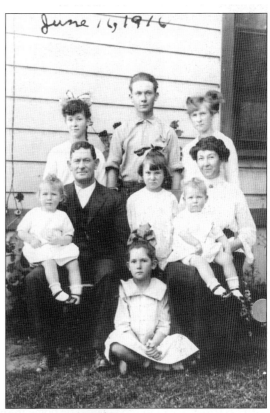

WELLS FAMILY. The Wells family included Judson and Jennie Wells, along with their adopted son, Michael Timis. They came to the area from Buffalo, New York, in 1914. The Wells family lived in a style not too common for their neighbors. They employed a chauffeur for their Winton touring car, had a household maid, and had a full-time bookkeeper.

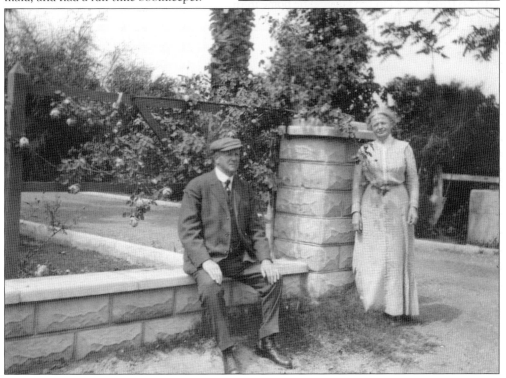

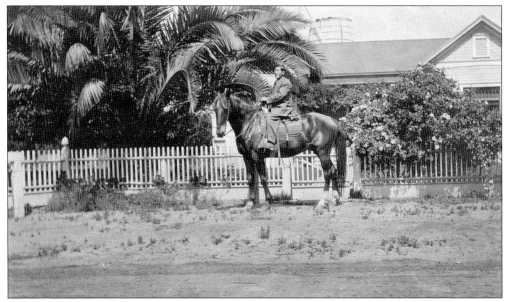

HARUZO NAGAI. Known around town as Dan, Nagai is seen here on a horse in front of the Edmonton House on Passons Boulevard in 1912.

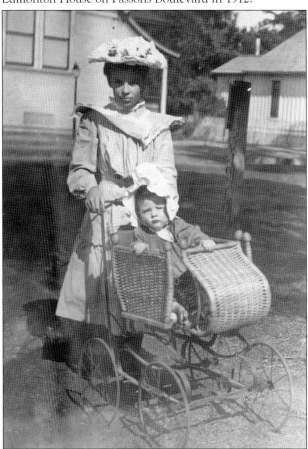

INA MILLER. Miller is seen here with her nephew, Harold Coward, in Rivera in 1906.

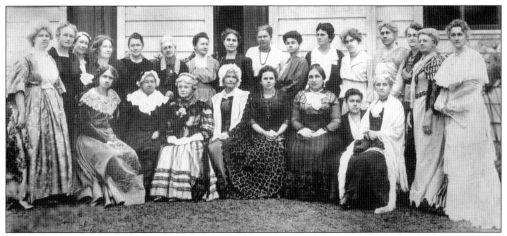

WOMAN'S IMPROVEMENT CLUB OF RIVERA, 1925. These club members were dressed in family heirloom costumes for the club's picture. From left to right are (seated) Mrs. M. B. Times, Mrs. Sam Burke, Mrs. George Harvey, Mrs. Will Hanna, Mrs. W. C. Newsom, Mrs. Ote Mordan, Mrs. George Triggs, and Mrs. ? Williamson; (standing) Mrs. Osburn Burke, Maggie Sawyer, Mrs. Edward Selby, Mrs. Joseph Williams, Mrs. F. C. Harvey, Mrs. ? Gilman, Mrs. T. B. Chapman, Annie Hunter, Mrs. Arthur White, Mrs. Jack Wyatt, Mrs. ? Haley, Mrs. Jack Shade, Emma Wells, Mrs. D. Wiebers, Mrs. A. J. Wells, and Mrs. Charles Anspach.

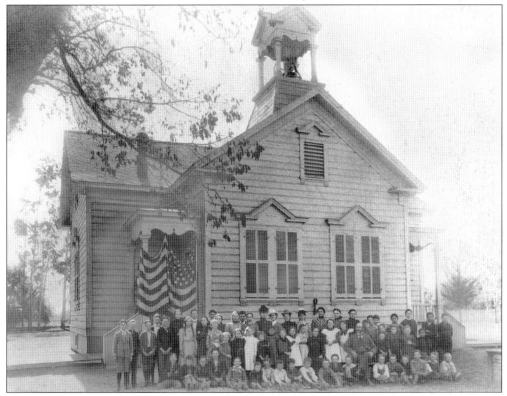

THE RIVERA SCHOOL HOUSE. Classes at the Rivera School House were discontinued in 1915, and in 1922, the Woman's Improvement Club of Rivera purchased the property and converted the building into a clubhouse.

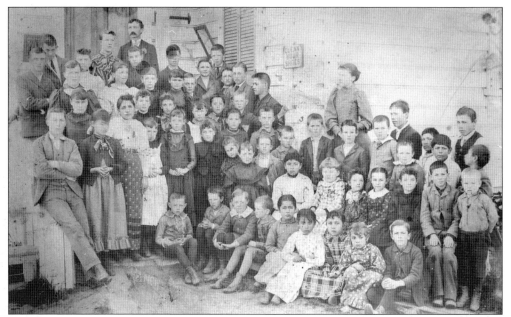

CHILDREN AT RANCHITO SCHOOL HOUSE, EARLY 1900S. The school bell that hung in the tower of this school may now be seen on the ground of the South Ranchito School. Until 1928, the Ranchito School on Passons Boulevard was the only school in the Pico District.

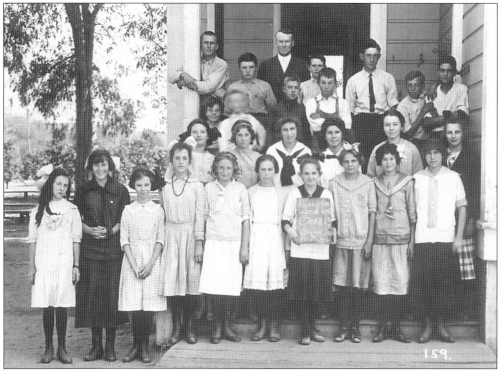

RIVERA GRAMMAR SCHOOL, 1913. This school was originally located on Serapis Avenue. Pictured among the other children are Jack Shade (third row, far right) and his future spouse, Ruth Reider (second row, far right).

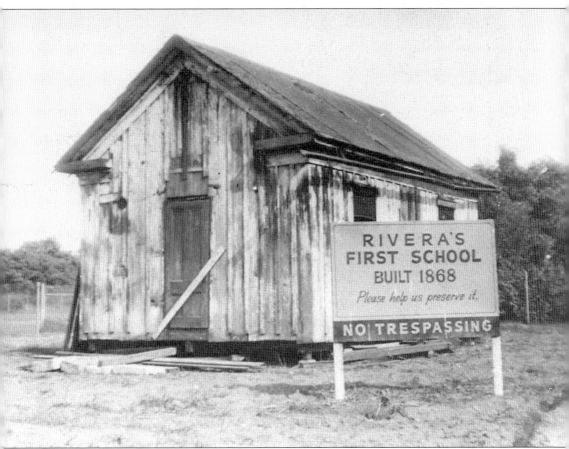

RIVERA'S FIRST SCHOOL. Maizeland School was built in 1868 and, following 27 years of useful service, was moved to the Albert MacDonald farm to be used as a utility building. The first location of the school was at 8910 East Slauson Avenue, then known as Shuggs Lane. In 1950, it was moved again to the Rivera School District grounds on Passons Boulevard as a museum. The museum effort later failed. It was then that Knott's Berry Farm accepted the historic structure. The structure has been restored and can still be seen at Knott's Berry Farm in Buena Park, California.

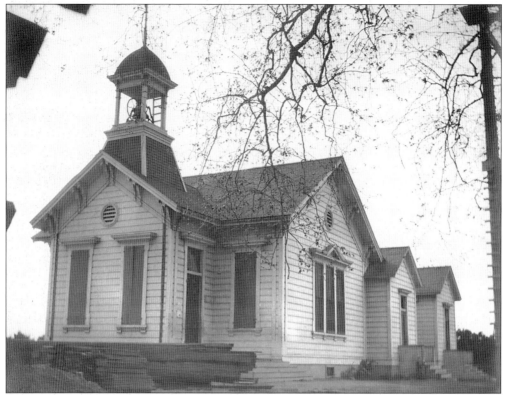

RANCHITO SCHOOL HOUSE. The first Ranchito school was located near the corner of Whittier Boulevard and Columbia Street. Later on, Ida Dunlap gave an acre of ground for a school on Passons Boulevard. Here a one-room schoolhouse was built. Another room was added in 1882 and a third room in 1905.

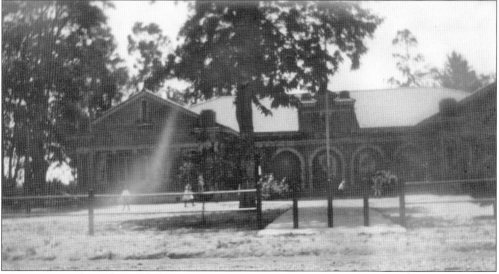

RIVERA SCHOOL. The second school in Rivera, the Rivera School was located on Shugg Lane. It was built in 1915. Today Shugg Lane is called Slauson Avenue. The Rivera School was remodeled and relocated after the 1933 earthquake.

BURKE MANSION. Probably the most impressive family home in the San Gabriel Valley, the Burke mansion was located on a spacious two and one-half acres at 7814 Passons Boulevard in Rivera. The structure was built in 1922 by Osburn Burke, the son of the pioneer Joseph H. Burke. Its site was originally the Burke Winery. There were three stories in the mansion. The upper floor was a ballroom. The total floor space was 6,600 square feet. The house was demolished for commercial development in the early 1980s.

THE MAULSBY RANCH. Owned by O. W. Maulsby and his son-in-law, C. L. Edmonston, this ranch was located where El Rancho High School is today on Passons Boulevard.

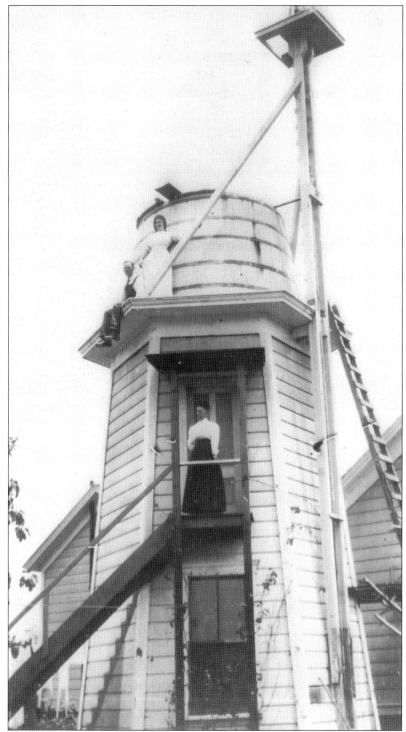

EDMONSTON FAMILY. C. L. Edmonston and his sister, Gertrude Edmonston Galloway, pose on the upper landing of the tank house, while Helena Rea Edmonston remains at a less precarious vantage place.

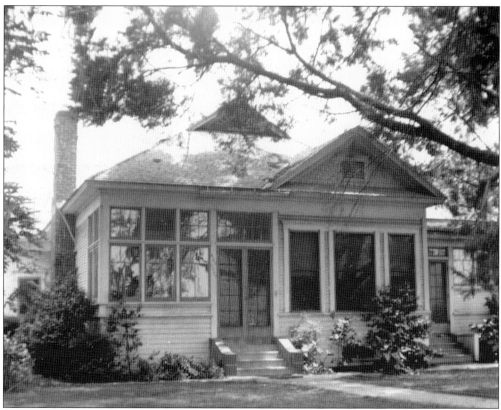

SHADE HOME. This house was the original Shade home built in 1895. John A. and Eulalia Burke Shade owned this home, as well as the Shade farm, which bordered old Rivera.

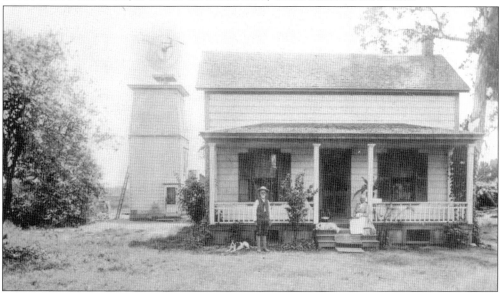

REIDER HOME, 1890s. This 60-acre ranch was located on Shugg Lane (now Slauson Avenue). Pictured are James and Mary Keister Reider, along with their dogs Ring and Spot. The Reiders moved to California from Columbia City, Indiana.

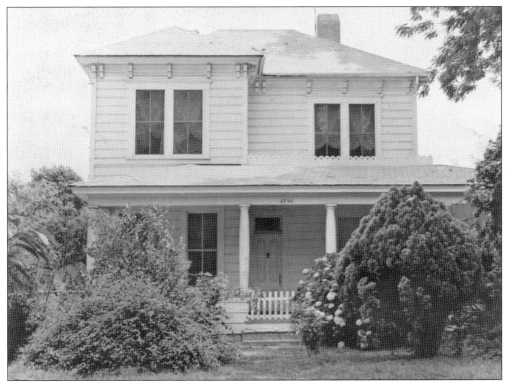

LYNCH HOME. Located at 6760 Passons Boulevard, the Lynch home was built in 1871. Garrett Lynch, who owned the home, was born in Ireland in 1830. At the age of 16, he journeyed to California. Lynch later became successful in a gold mining venture and married Abigail Lynch. In 1871, he settled in Rivera where he had 48 acres of walnut groves. The Lynch home was demolished in 1962.

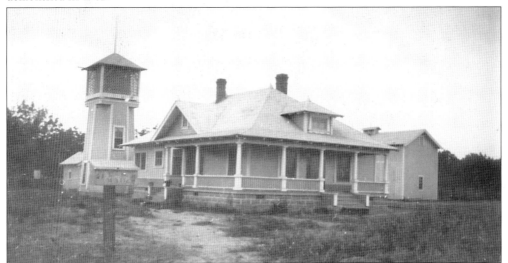

E. J. BOYCE HOME. Edgar J. and Lois Meff Boyce acquired 10 acres on Cate Road (now Durfee Avenue) around 1900. When the Union Pacific Railroad secured a right-of-way for their tracks, it cut off a piece of the property. Oranges and then walnuts and persimmons were the mainstay crops.

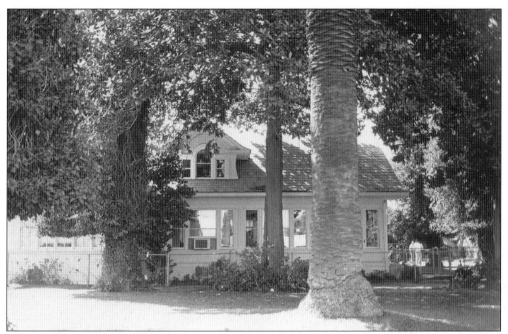

WELLS HOME. Located on 90 acres on Passons Boulevard, this property was given the name Rancho Venturilla. The home had the distinction of having one of California's earliest solar systems for heating water. The palm tree located in front of the property was planted by Dr. Ozmun, who owned the property prior to the Wells family. The trees were planted not only in his yard, but also on both sides of Passons Boulevard.

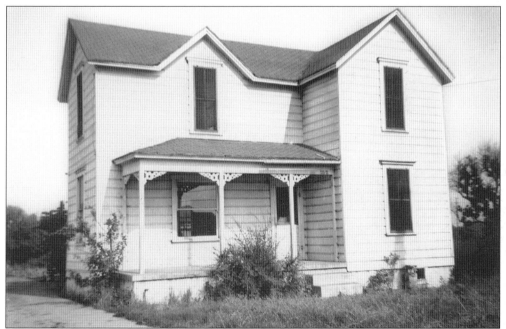

WHITE HOUSE. Located at 9128 Burke Street, this house was part of an old ranch in Rivera. Frank White, grandson of Walter W. White, was involved in real estate and was instrumental in helping to develop the Pico and Rivera communities since the early years of World War II.

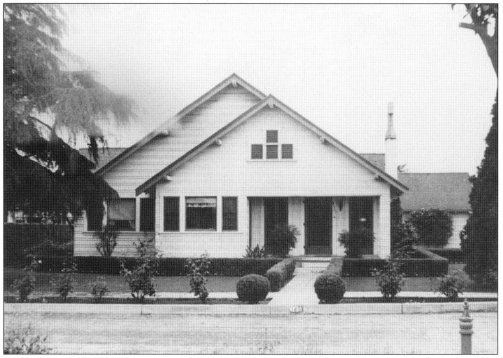

CATE HOUSE. Built in 1905, this house was located on Durfee Road. Harlan and Maude Cate resided here along with their only child, Shirley, well into the 1960s.

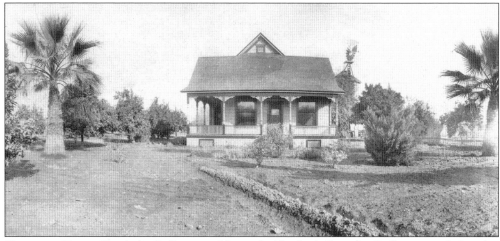

COFFMAN HOME. Frank A. Coffman and his wife, Elizabeth Stanifer Coffman, resided at this farmhouse and raised their seven children there. Demolished in 1962, this farmhouse was located at the busy intersection of present-day Rosemead and Whittier Boulevards.

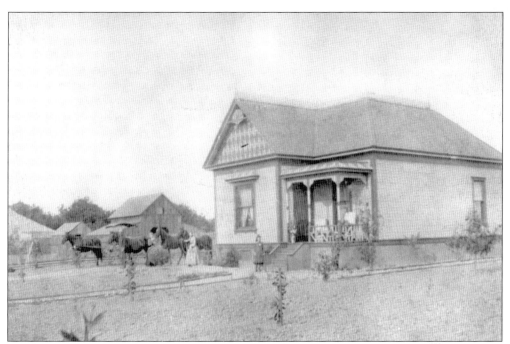

HAYNES HOME. J. G. B. Haynes proudly includes horses in the family farm picture, a scene at Shade Lane and Orange Avenue. Haynes settled in the Rivera area in 1875.

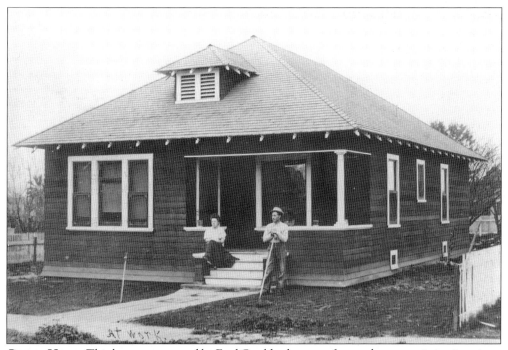

GOULD HOME. This home was owned by Fred Gould, who manufactured concrete irrigation pipes. Fred Gould spent most of his life on this farm. This home was built in 1885 by Fred's father. He would later own a second home on the same property. The site of the two homes is today the Birney Elementary School.

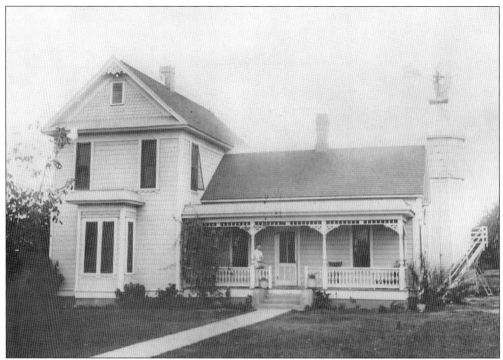

HARVEY HOUSE. Originally built on the George M. Bullock property on Orange Avenue, this house was later moved to Rosemead Boulevard. F. C. Harvey started a cement pipe–making business next door. Harvey also served as the Rivera postmaster for many years prior to 1933.

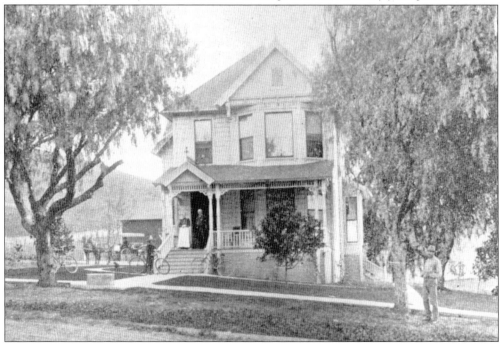

C. W. HARVEY HOUSE. Clinton Harvey succeeded his father as operator of the family cement pipe–making business, which was still in operation in 1962.

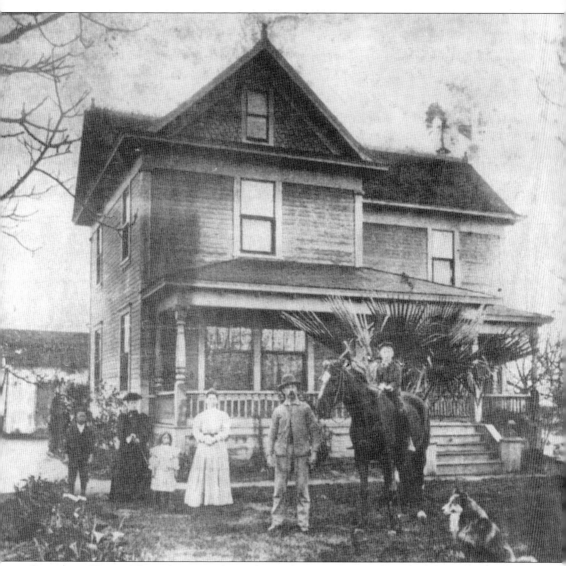

CHAPMAN HOME. This 36-acre ranch was located on Passons Boulevard, about a quarter mile north of the Santa Fe tracks. The ranch was purchased in 1895 from Monroe Passons, whose father, Oliver P. Passons, was an early pioneer. When Thomas Chapman bought the ranch, it was already planted with walnuts. He brought his wife, baby son, and nearly all the members of the Chapman clan. While harvesting walnuts in the early years, the family maintained a self-contained community on the ranch.

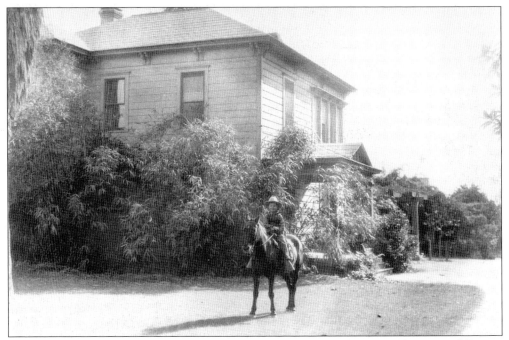

HAAG HOME. This home was once converted into a two-story structure. George and Fannie Haag's family included Elizabeth, Robert, Margaret, and Walter (pictured on his pony). Besides his agricultural pursuits, George Haag served as a trustee of the Ranchito School District.

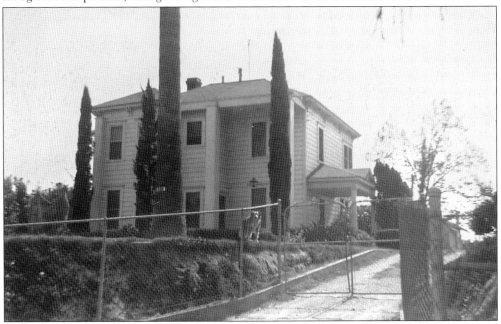

G. HAAG—BARLOW HOUSE. This home, located at 8612 Dunlap Crossing Road, remains one of the impressive homes in the community. On this 76-acre ranch, James Barlow built a modest single-story dwelling in 1897. The Barlows' niece, Fannie Trailer, eventually married George Haag, and for a wedding gift, they received the home place of the Barlows. George and Fannie Haag rebuilt the home into the two-story structure pictured here.

FRANK COFFMAN HOME, 1931. This was the second Coffman home, built in 1924 in the same area as their previous home, somewhere near Whittier and Rosemead Boulevards. In February 1962, the doom of progress consigned this fine old landmark to a pile of rubble. Pictured is Elizabeth Coffman with her son, Marshall, and grandson Robert Flory.

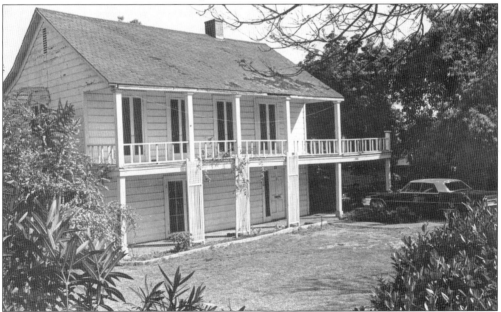

CLARK HOME. The Clark house was located on 15 acres at 8310 Orange Avenue and owned by Chauncey Clark. He purchased the property in 1912. He would later sell the property to R. D. Clark, a relative, in 1920 and move to Santa Fe Springs.

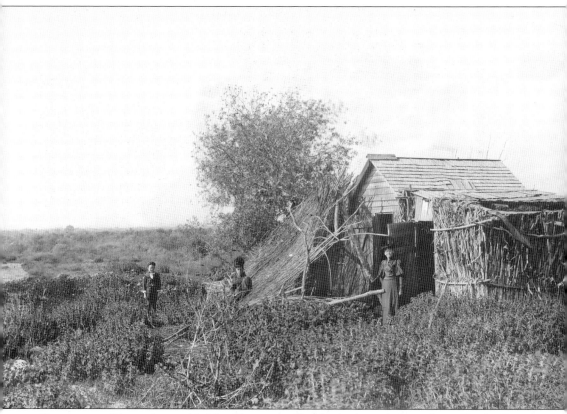

CARALAMBO HOME. Located in Pico Rivera, the Caralambo home belonged to a Greek, George Caralambo, one of the last survivors of the historic U.S. Army Camel Corps. The Camel Corps was an experiment by the United States in 1857 to resolve the transcontinental transportation problems facing travelers as they crossed waterless stretches of terrain to reach the West Coast. Although the Camel Corps successfully traveled from Fort Defiance, Albuquerque, New Mexico, to California, no further use was made of the camels. Later Highway 66 and the Santa Fe Railroad followed their trail-breaking route. George remained in this country after being discharged and resided here until his death in 1913.

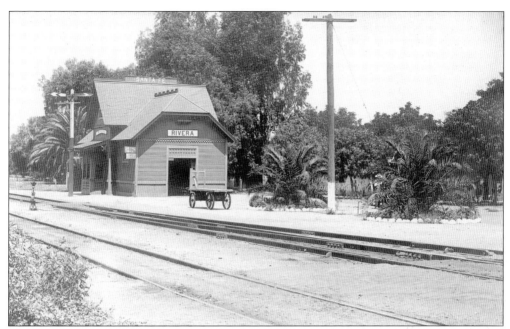

SANTA FE DEPOT, 1900s. The Southern California Railroad Company, later acquired by the Santa Fe Railroad, laid tracks out of Los Angeles that would extend to San Bernardino by way of Anaheim, Orange, and Riverside. Note the extensive orange groves next to the depot.

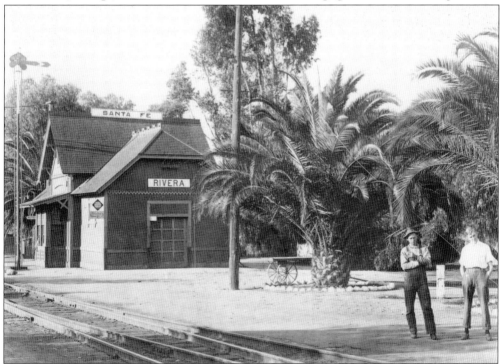

SANTA FE DEPOT, C. 1900. Joseph H. Burke, one of the original founders of the Rivera town site, was instrumental in having the railroad routed through the new town of Rivera while it was still being developed.

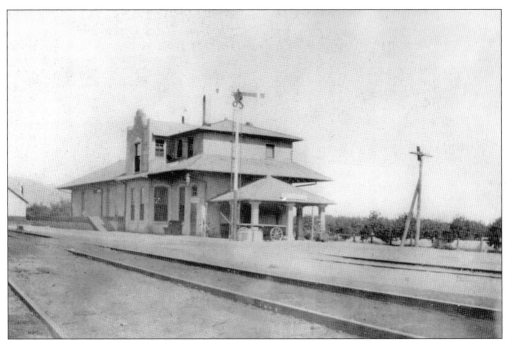

UNION PACIFIC STATION. The Union Pacific station, located in Pico, eventually met its demise along with thousands of other depots when airlines superseded passenger train service.

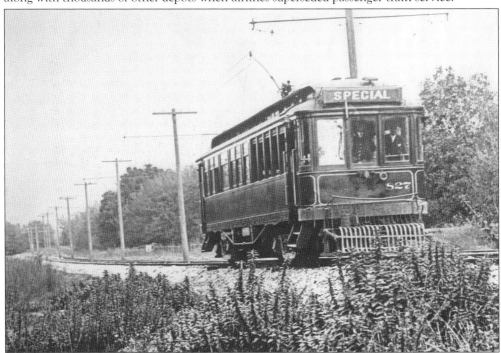

THE PACIFIC ELECTRIC. Here the "big red cars" are seen around 1904 between the city of Whittier and the community of Rivera with present-day Whittier Boulevard beyond the curve in the background. The trip from Rivera to Los Angeles took 31 minutes. Former president Richard Nixon's father was a motorman on this line.

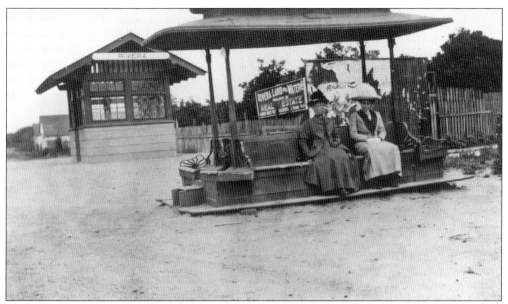

THE PACIFIC ELECTRIC RAILWAY DEPOT. This is the depot as it appeared about 1910. The "big red cars" continued to operate on a fast interurban schedule until 1938, when they were discontinued.

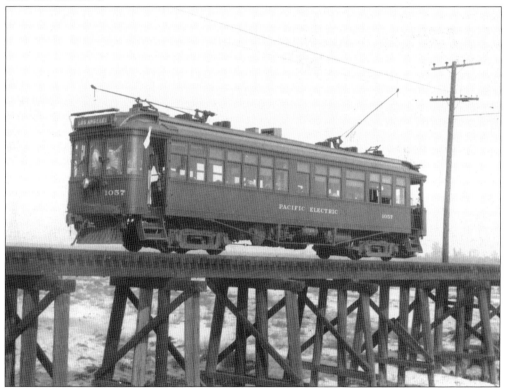

LAST RUN FOR THE BIG RED CARS. The commemorative run was in 1947. Immediately after this, the overhead trolley wires were removed and the track began serving diesel freight trains. Here Big Red Car No. 1057 pauses on a bridge over the dry San Gabriel River for a historic picture.

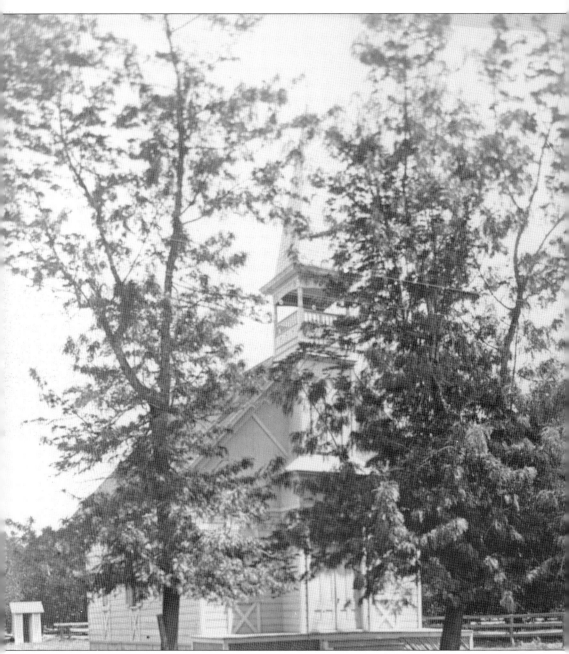

Presbyterian Church. James Fletcher Isbell stepped forward and donated a lot on present-day Slauson Avenue and on the first block east of Rosemead Boulevard for the Presbyterian church. When the church was first erected, it stood on the opposite side of the street, almost facing the First Baptist church. About 1912, the Presbyterian church building was sold and moved to the corner of Dunlap Crossing Road and Passons Boulevard. The building was eventually torn down in 1962 to make way for the widening of Mines Avenue.

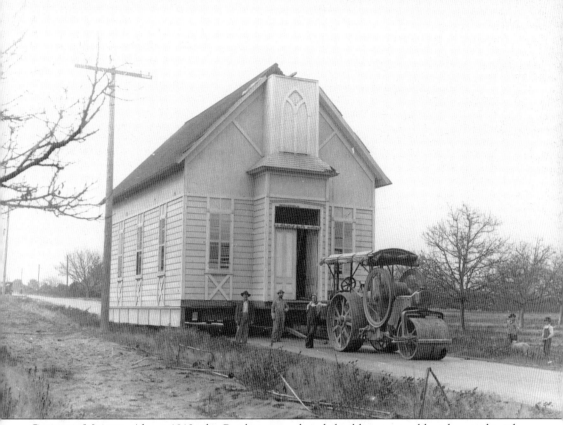

CHURCH MOVED. About 1912, the Presbyterian church building was sold and moved to the corner of Dunlap Crossing Road and Passons Boulevard. The church then served as the clubhouse for the Pio Pico Woman's Club. When the relocated Presbyterian church became available in 1916, the club members drove in their buggies from farm to farm soliciting donations. They were successful, and the quaint building with stained-glass windows became their clubhouse, serving them for 40 years.

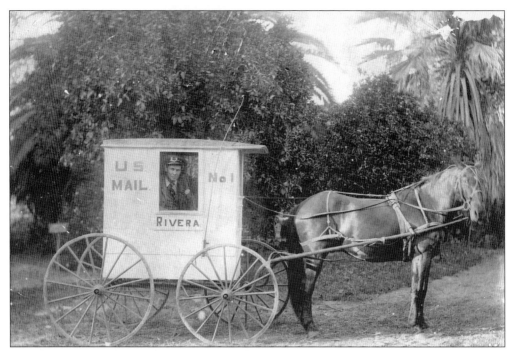

RIVERA MAILMAN, C. 1900. Mr. Sasson made his appointed rounds of mail deliveries through Rivera.

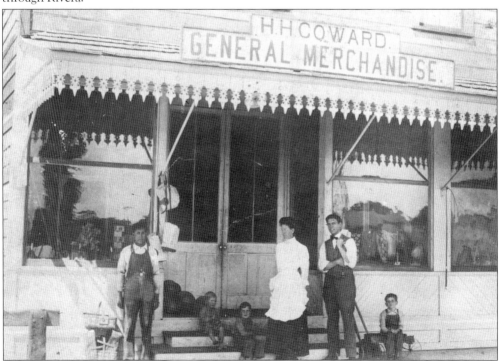

COWARD'S GENERAL MERCHANDISE. This store at the corner of Serapis and Slauson Avenues served the community for many years. Appearing in the picture are Reta and Hume Coward standing at center.

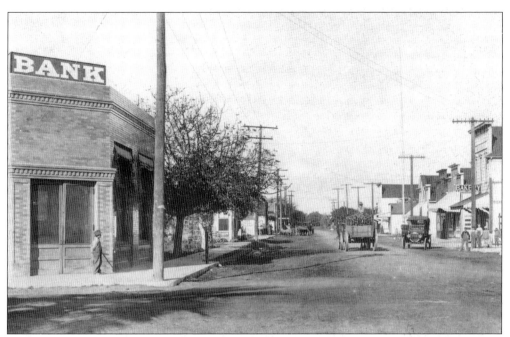

CORNER OF SLAUSON AND SERAPIS AVENUES, 1913. The yellow brick building appearing here in 1913 served as the Rivera State Bank during World War I until it failed with the Depression. Osburn J. Burke, as vice president and one of the last directors, fought unsuccessfully against its closing in 1932. The building was demolished in 1957 to permit the widening of Slauson Avenue.

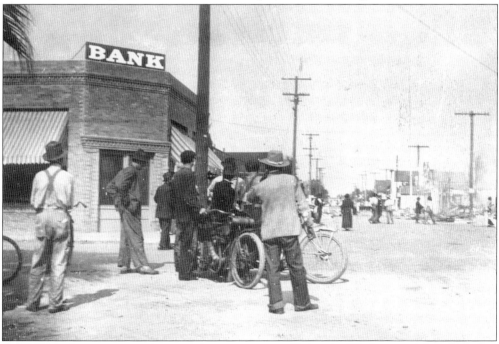

CORNER OF SLAUSON AND SERAPIS AVENUES, 1920. Today the Washington Mutual Bank is opposite the site pictured. When a devastating fire reduced five store buildings to ashes, the area was rebuilt with brick structures, as pictured here in 1920.

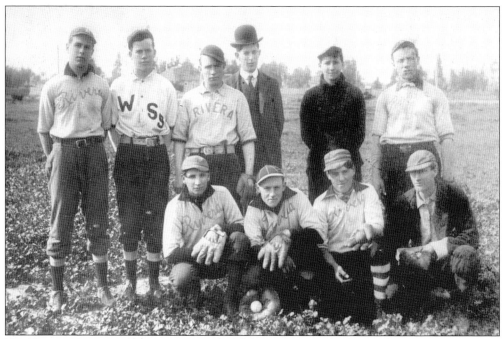

THE RIVERA BASEBALL TEAM OF 1903. This club is only partially identified, with the list reading, from left to right: Fred Snodgrass, George William Ellis, ? Morrison, ? Bradford, ? Bristwalter, Andrew Broadbent, ? Louglin, Ray Broadbent, ? Lucero, and ? Isabell.

RAY BROADBENT AND GEORGE WILLIAM (RUBE) ELLIS. Broadbent and Ellis played with Los Angeles in the Pacific Coast League in 1906. Broadbent played shortstop, and Ellis was in left field. Both appear in this photograph. In the group, Ellis is standing second from right and Broadbent is kneeling third from right.

SAM "WAHOO" CRAWFORD. Crawford lived in Pico Rivera through his retirement years up to the time of his death in 1968. He had a long, distinguished career, mainly with the Detroit Tigers. He played from 1899 to 1917. Crawford retired with a lifetime batting average of .309 and was inducted into the Baseball Hall of Fame in 1957.

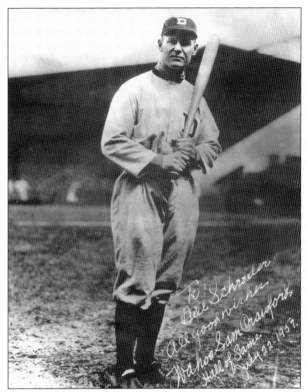

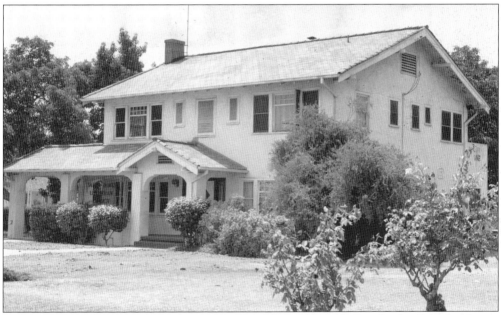

CRAWFORD HOUSE. Located at the corner of Durfee and Beverly Roads, the Crawford house was affectionately known as "Wahoo Sam's Home Plate." Here lived Samuel E. (Wahoo Sam) Crawford, one of baseball's immortals, with his wife, Ada; son, Samuel; and daughter, Virginia. Crawford achieved fame playing in the outfield for the Detroit Tigers during the days of Ty Cobb. He passed away in 1968.

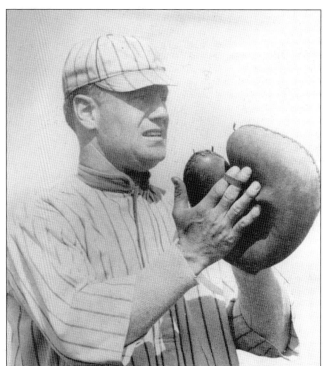

JACK BLISS. Bliss began his baseball career with Oakland in 1906. From 1908 to 1912, he caught for the St. Louis Cardinals. In five years of playing, his batting average was .219. Jack lived in Pico Rivera during his playing years until the time of his death in 1968.

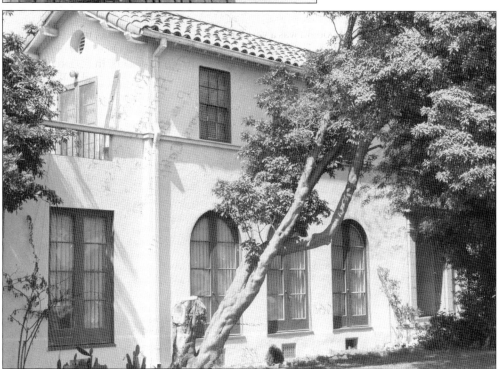

BLISS HOUSE. Located at 5537 Rosemead Boulevard, the Bliss house represented one of the rewards of a career in baseball. Living with Jack Bliss in this home was his wife, Irene Wanderlich Bliss, and their daughter, Mary Jane.

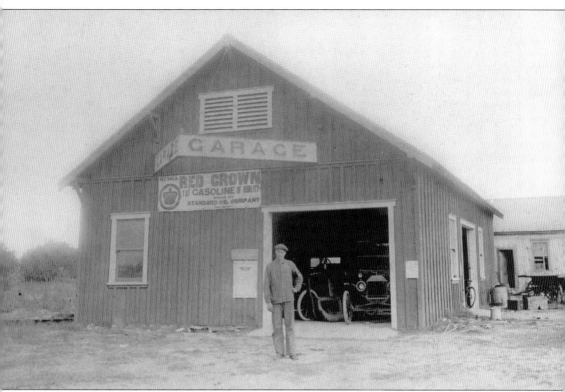

ALBERT F. MACDONALD. MacDonald was a very successful entrepreneur who, in 1911, became a Ford distributor with agencies from Los Angeles to Orange County. MacDonald would have the cars assembled at a Rosemead garage and then have them driven to dealers. In his later years, he would give several million dollars to the Shriners Hospital. His home was located at Washington and Passons Boulevards. He died on August 27, 1971.

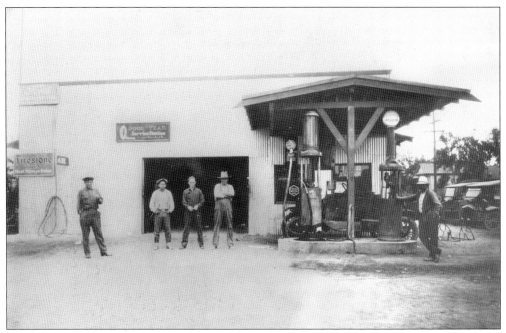

BILL'S GARAGE. Shown here in 1924, Bill's was located at the corner of Serapis Avenue and Bermudez Street. In contrast to today's high price for gasoline, it sells here for only 10¢ a gallon.

CHARLES AND HAROLD GROVER. Charles operated a garage at the northwest corner of Rosemead and Beverly Boulevards. Charles (left) is pictured with his nephew Harold (right).

LELAND A. CUPP AMERICAN LEGION POST NO. 341. This picture was taken shortly after the American Legion post was chartered on October 28, 1929. The location is on Durfee Road just north of Whittier Boulevard.

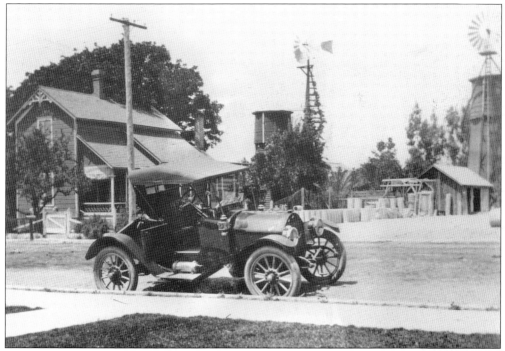

FRED GOULD HOME. Pictured is the first of two homes for Fred Gould. Note the glimpse of concrete pipes. Fred Gould spent the majority of his life on this ranch. The site of the ranch is today the Birney Elementary School.

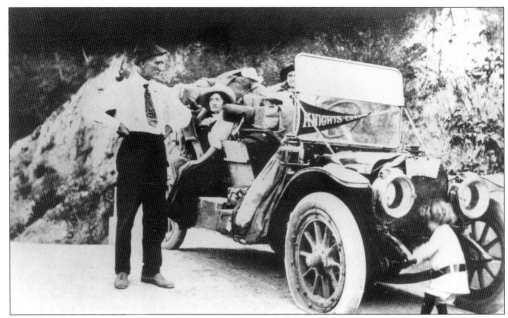

O. W. MAULSBY. Maulsby was photographed as he pondered the perplexities of fixing a flat tire while on a drive to Big Bear.

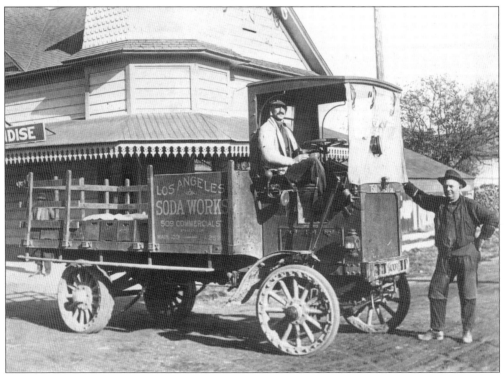

SODA DELIVERY. These early trucks delivered soda to Rivera in 1913.

Two
A Tale of Two Cities

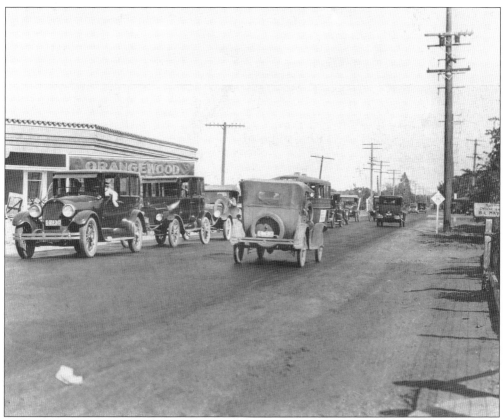

TELEGRAPH ROAD. At the time of this c. 1902 photograph, this street was known as Anaheim-Telegraph Road. The Orangewood development was one of the first major real estate developments in the area of Rivera.

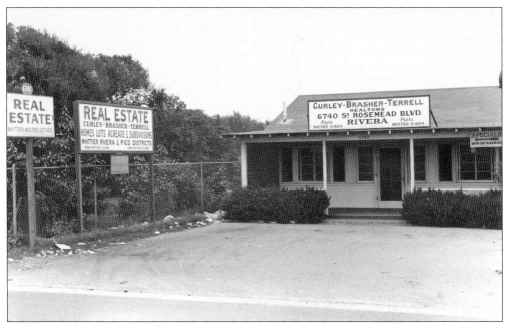

REAL ESTATE DEVELOPMENT, 1950s. When the communities of Pico and Rivera continued to grow in the early 1950s, real estate developers began subdividing the land to make room for housing.

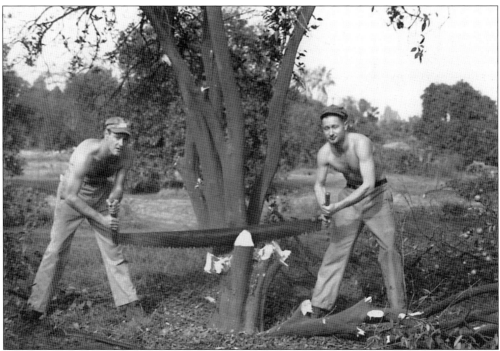

REMOVAL OF ORANGE TREES. Pictured are Mike Hertel (left) and his brother Frank as they cut down orange trees in Rivera sometime in 1943 or 1944.

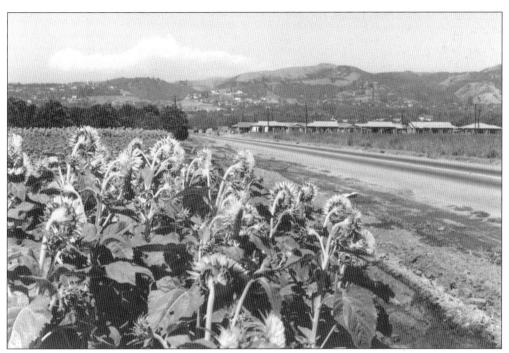

AGRICULTURAL PAST. This picture shows the gradual change that transpired in Pico Rivera after World War II. On the left side of the picture is an open grass field, a common sight in the past. Across the street, on the right side of the picture, is a housing development.

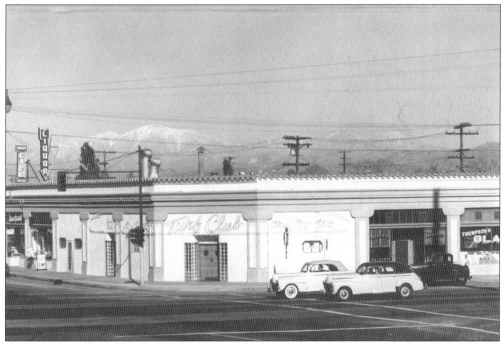

ROSEMEAD BOULEVARD AND ANAHEIM-TELEGRAPH ROAD, 1940S. This street scene shows the intersection of Rosemead Boulevard and Anaheim-Telegraph Road in Rivera. The Turf Club was located on the northeast corner of the intersection where the Pedregal Club now resides.

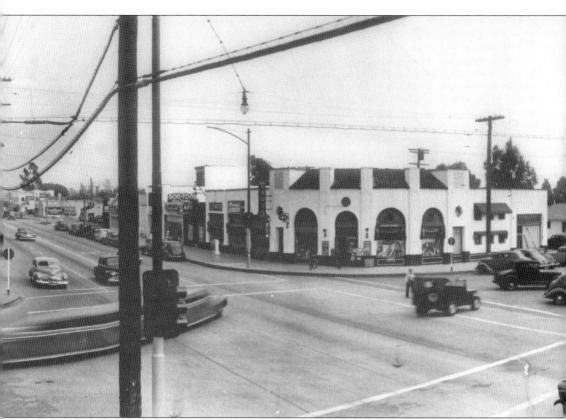

WHITTIER BOULEVARD AND DURFEE AVENUE, 1930s. The above picture of this busy intersection has the camera positioned on the north side of Whittier Boulevard looking

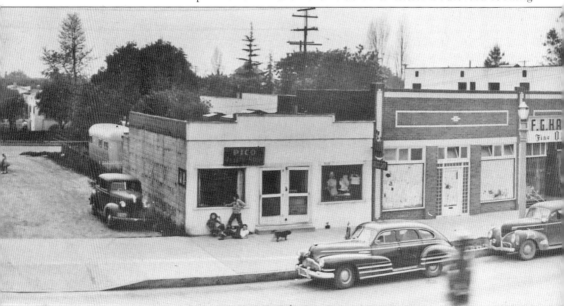

WHITTIER BOULEVARD, LOOKING WEST, 1930s. Not until after World War II was there an accelerated growth in this area. At that time, Pico was still in the midst of an agricultural

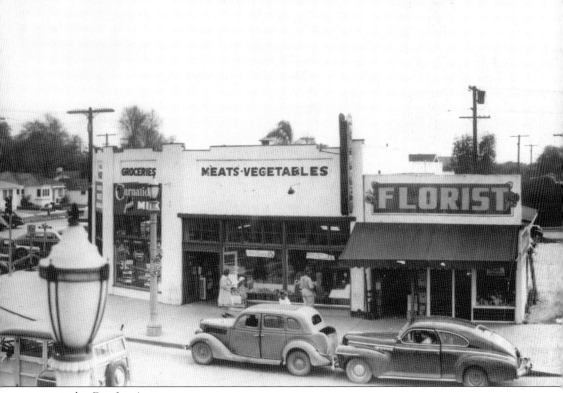

east at the Durfee Avenue.

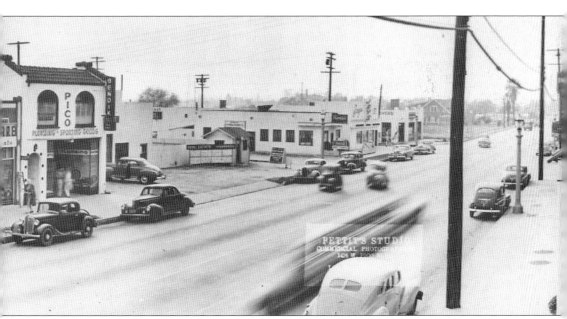

community. To the west just outside the camera's view are orange groves bordering the boulevard.

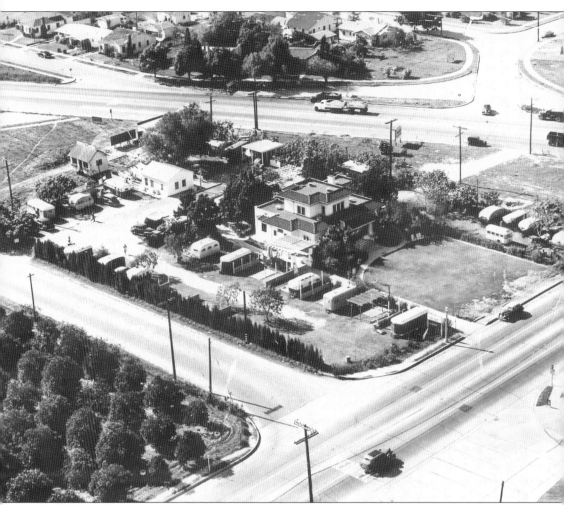

THE CHARLES WARREN—RAY REESE HOME. This aerial view was taken of the home located at 9022 Whittier Boulevard. It was built in 1898 by Charles Warren, a real estate developer. In 1936, the property was purchased by Ray Reese, the principal of the North Ranchito School. He would later become the superintendent of the Ranchito School District. This 1942 aerial view features a trailer court on the grounds. Rosemead Boulevard is in the background; the house faces Whittier Boulevard. Note the orange groves lined up on Whittier.

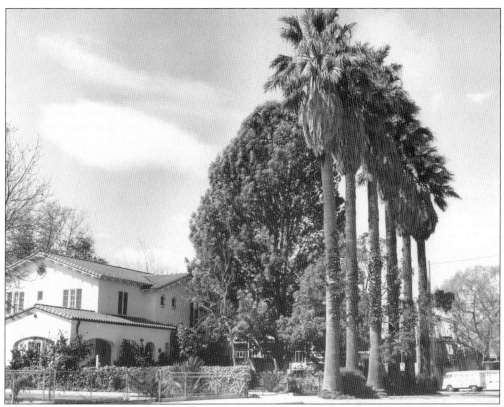

L. W. Houghton House. Located on Burke Street, the L. W. Houghton house was built in the 1920s.

Fred Gould and Pearl Ellis. Fred was a longtime resident of Pico Rivera. After his wife, Jess Gould, passed away in 1944, he married Pearl Ellis, the widow of famed baseball player Rube Ellis. This home is today the site of the Birney Elementary School.

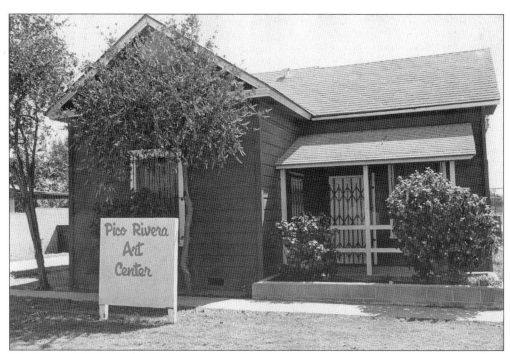

PICO RIVERA ART CENTER. This was originally the ranch house of Herbert and Martha White. It was built early in the 20th century. It was later donated to the city and used as an art center.

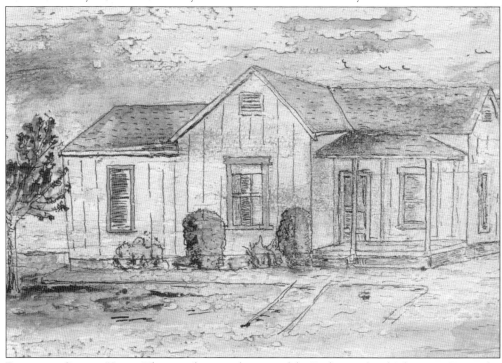

BERMUDEZ STREET HOME. This pastel crayon drawing of the Rodriguez family's home on Bermudez Street in Rivera was drawn by Daniel Rodriguez. He lived in this home with his parents, Elvira and Trinidad Rodriguez, during the 1930s.

FIRST BAPTIST CHURCH. This church was built in 1888. It was first located on the southeast corner of Slauson Avenue and Rosemead Boulevard on land donated by pioneer J. F. Isbell. In 1916, the church was moved to its present location at the corner of Burke Street and Serapis Avenue.

WOMAN'S IMPROVEMENT CLUB. This building has stood for many years in Rivera. It had been used by the Woman's Improvement Club as a dance hall and later for the Pentecostal Foursquare Church.

WHITTIER BOULEVARD BUILDING. This structure, located on the north side of Whittier Boulevard just west of Durfee Avenue, has been at this site for years. It was originally used as a bank and has recently been converted for use as a tortilleria.

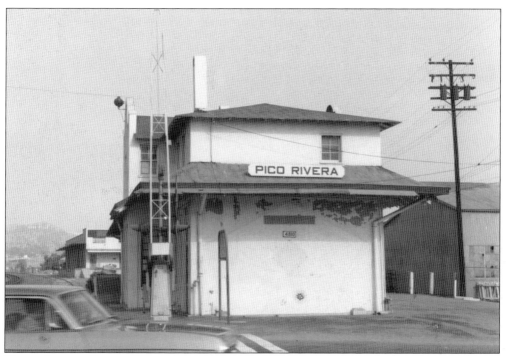

UNION PACIFIC DEPOT. This picture was taken just before the depot met its demise. The depot was located just north of Whittier in the Pico area.

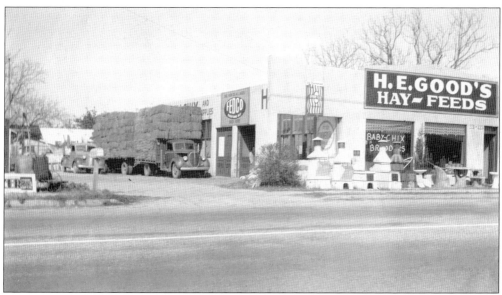

H. E. GOOD'S HAY AND FEED. This company was started in 1937. Harold Good; his wife, Estele; sons, Bernard and Gerald; and daughter, Maureen, all helped to make the business a success.

GERALD GOOD, C. 1937. Pictured is Gerald, a son of Harold Good, along with his pony, Trunket.

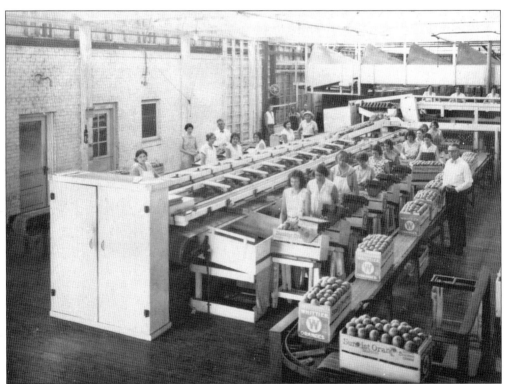

RANCHITO CITRUS PACKING HOUSE, 1930S. Shown during a busy day are workers at the packinghouse, which was located in Rivera on Bermudez Street.

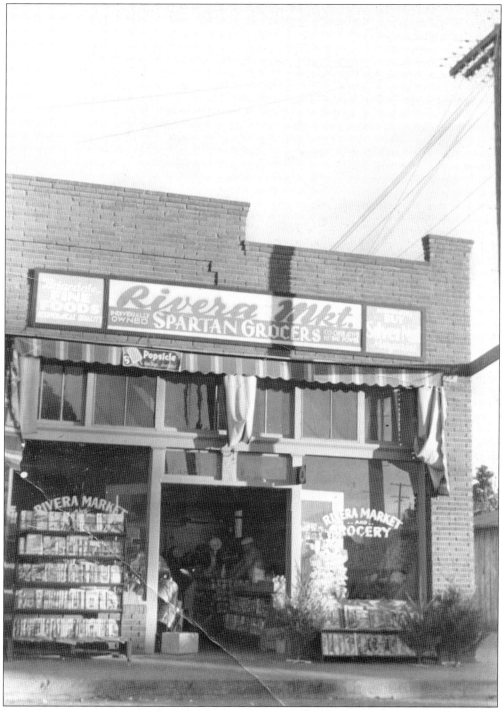

RIVERA MARKET. This market was founded in 1906 by Fred Rothaermel. It was a general store for many years, but as other stores came into the area, it switched to handling only groceries and meat.

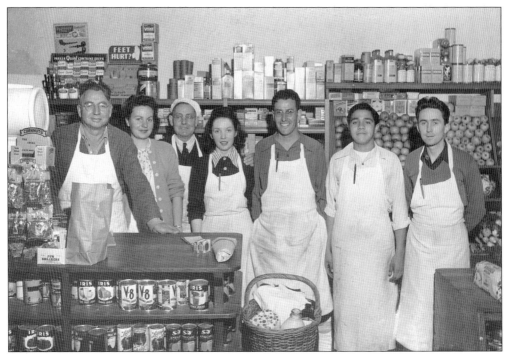

INSIDE RIVERA MARKET. The market located at 7712 Serapis Avenue continued in existence for many years. When this picture was taken in the 1940s, the store was being operated by Leslie and Freida Rothaermel Conley. In 1962, it was occupied by a Rothaermel granddaughter, Nancy Conley Nash, along with her husband, John Nash.

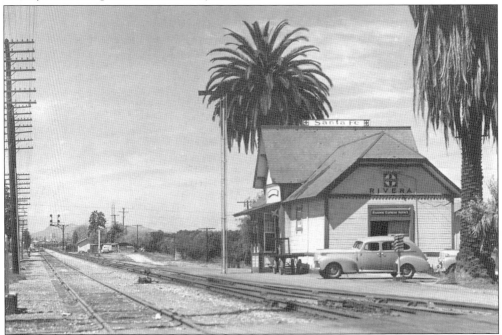

SANTA FE DEPOT. This picture was taken in the 1940s. The depot was located on the south side of Rivera.

ST. FRANCIS XAVIER CHURCH. The first Catholic church in Pico was on the corner of Isora Road and Maris Avenue. Children pose after their first Holy Communion at St. Francis Xavier Church in the 1920s.

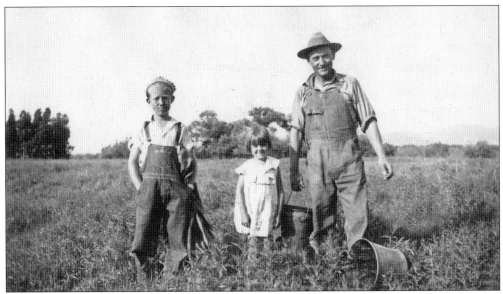

BULLOCK FAMILY. The Bullock family owned 60 acres of pasture land on Dunlap Road. In this 1938 photograph is Earl Bullock (right) with his children Vern (left) and Virginia (center).

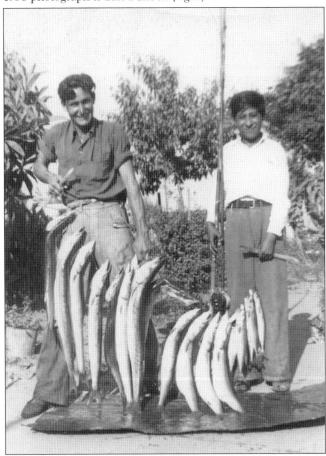

PICO PARK, 1941. Timoteo G. Morales (left) and Martin Garcia, residents of Pico, are photographed posing with the barracuda they had just caught while fishing.

ESPINOZA FAMILY, 1940S. This picture was taken on the Rancho De Don Daniel, today called the Bosque Del Rio Hondo Natural Area. Pictured from left to right are Jose Espinoza, Lucy Tovar, and Emily Espinoza.

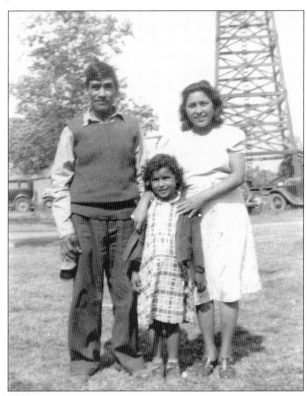

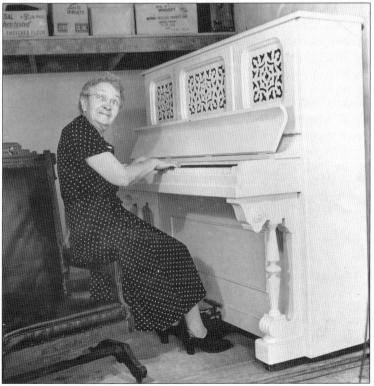

PIANO TEACHER, 1953. Pictured is Mrs. Bradford, daughter of Bird Passons. She was well known in the community not only as a descendant of the Passons family, but also for giving piano lessons to many in the area.

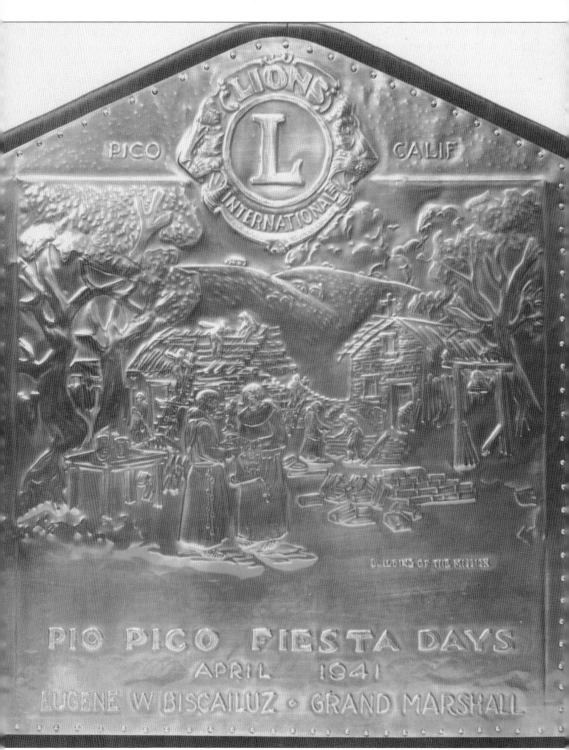

Pio Pico Fiesta Days, 1941. The fiesta, sponsored by the Lions Club, carried with it fun and frolic and something of a carnival spirit. Its purpose was for the community of Pico to feel something of spirit and brotherly love, cooperation, and good fellowship.

ST. HILARY CHURCH, 1950S. Rev. Percy J. Bell of St. Hilary Church is posing here with Chief Iron Eyes. Later Reverend Bell was to become Monsignor Bell.

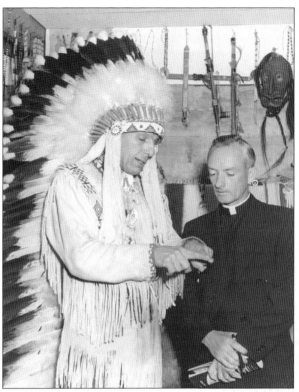

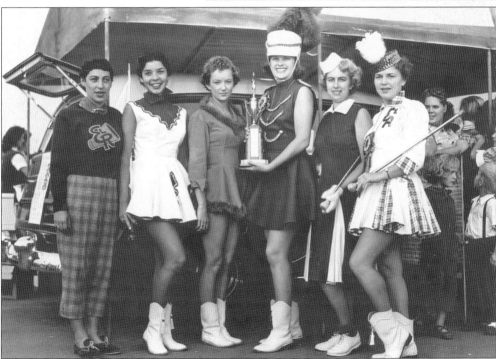

PIO PICO FIESTA DAYS, 1953. Posing here at St. Hilary Church are members of the El Rancho High School cheering squad, Donette drill team, and head drum major and majorettes.

SOUTH RANCHITO SCHOOL. This school had its beginnings in 1872 in a building near Columbia Street and Whittier Boulevard. In 1920, the frame building was replaced by a brick building. It was later damaged in the 1933 Long Beach earthquake, and a replacement, along with additional acreage, was purchased in 1950.

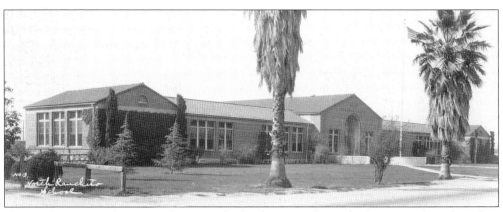

NORTH RANCHITO SCHOOL. The original school site was located on Rosemead Boulevard. It was built in 1928. This building was later demolished as the school had to meet the demands of a growing community.

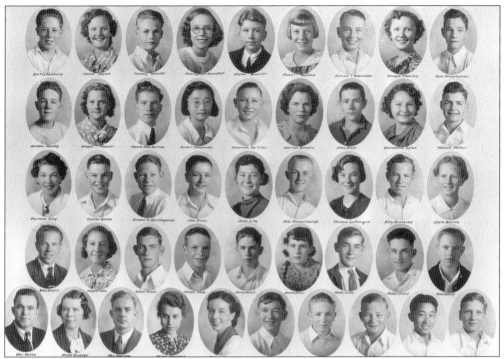

NORTH RANCHITO SCHOOL, 1937. This school was the second school to be constructed in the Ranchito School District. In fact, the first kindergarten class in the district was established at North Ranchito School. Among the students pictured in the class portrait is Ronald Drake (second row, third from the right). He would later marry Frances Sidwell, who still resides in Pico Rivera and is a current member of the Pico Rivera History and Heritage Society.

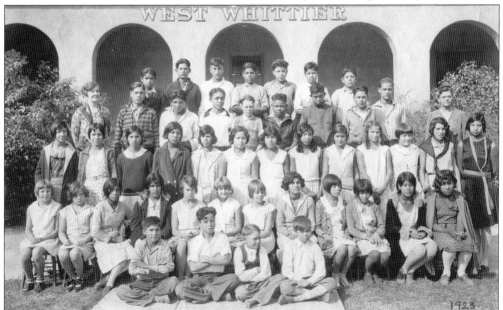

WEST WHITTIER SCHOOL, 1923. This school picture was taken near Jimtown, which was located on the outskirts of Pico Rivera.

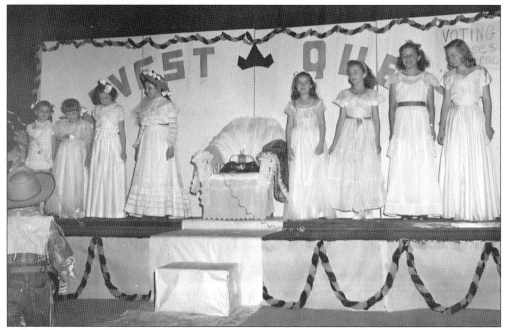

HARVEST QUEEN PAGEANT. This pageant took place sometime in the early 1940s as part of the festivities at Rivera Grammar School.

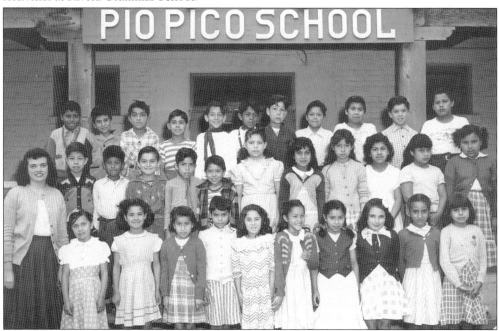

PIO PICO SCHOOL, 1950. The Pio Pico School is located in the Pico area. Originally built in 1931, it was the third school to be built in the Ranchito School District. The original structure was not large enough to accommodate a growing population, so more land was purchased and the school was rebuilt. A cafetorium was added early in the 1960s. Rumors have existed for years that the school sits in the area where early Mexican inhabitants hid buried treasure. Although excavations have taken place, no treasure was ever located.

Three

A NEW BEGINNING

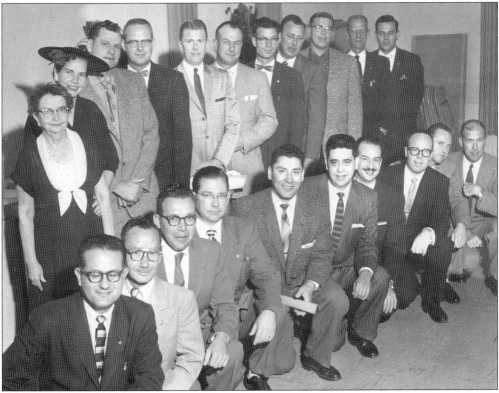

PICO RIVERA COUNCIL CANDIDATES, 1958. The election of 1958 to incorporate the communities of Pico and Rivera had four issues on the ballot. The first dealt with supporting incorporation. The second had to do with naming the city either "Pico Rivera" or "Serra City." The third had to do with selecting a council-manager form of city government, and the final issue dealt with selection of the first city council. Pictured here are 21 of the 24 candidates running for five seats on the city council. Only those in favor of incorporation are pictured above. They are, from left to right, (first row) Robert Davis, Howard Rogers, Henry Purnell, Don Switzer, Louis Diaz, William Figueroa, James Patronite, John Davis, Ray Norvedt, and Herman Huls; (second row) Vina Hively, Ruth Benell, Charles Humber, William Brakhage, Charles Snyder, Orlyn Culp, John Wellborn, R. A. Anbro, Lloyd Manning, John Gordon, and Robert Chalmers.

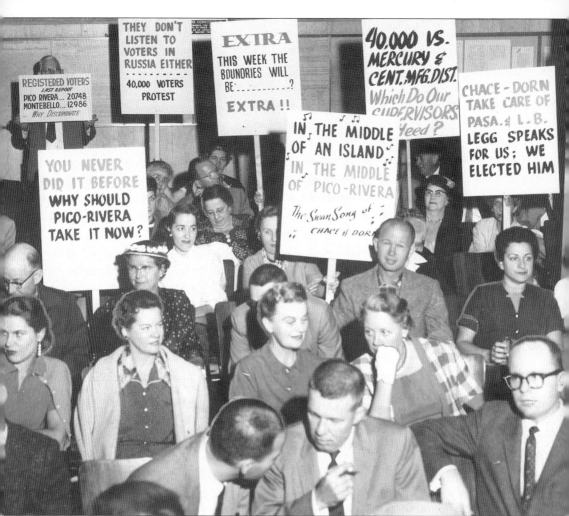

FORD-MERCURY PLANT PROTEST. This protest, held in late 1957, opposed a motion to exclude the Mercury plant from being incorporated into the proposed city of Pico Rivera. The motion was decided by a 3-2 vote following a long discussion before the board of supervisors. Voting for the inclusion of the Mercury plant along with an adjacent strip of land belonging to the Santa Fe Railroad were supervisors Herbert C. Legg, Kenneth Hahn, and John Anson Ford. Supervisors Burton W. Chace and Warren M. Dorn voted to exclude the huge plant from the incorporation.

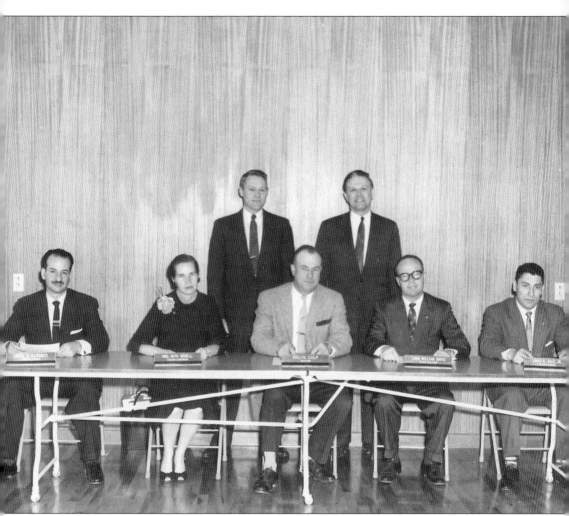

PICO RIVERA'S FIRST CITY COUNCIL, 1958. Pictured from left to right are (seated) James Patronite, Ruth Benell, Mayor Orlyn Culp, Vice Mayor John William Davis, and Louis Diaz; (standing) City Manager Frank Aleshire and city attorney John Todd. James Patronite served as city councilman from the time of incorporation until the municipal election in April 1958, when he was replaced by Lloyd A. Manning as city councilman.

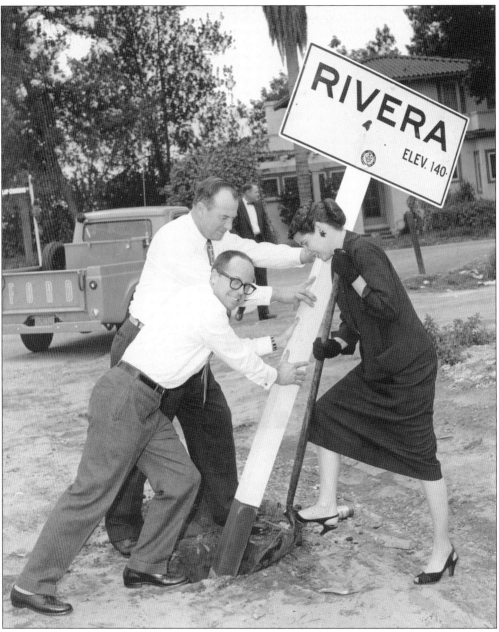

REMOVAL OF CITY MARKERS. Pictured from left to right, John Davis, Orlyn Culp, and Ruth Benell remove the old Rivera city markers to make room for the new Pico Rivera markers.

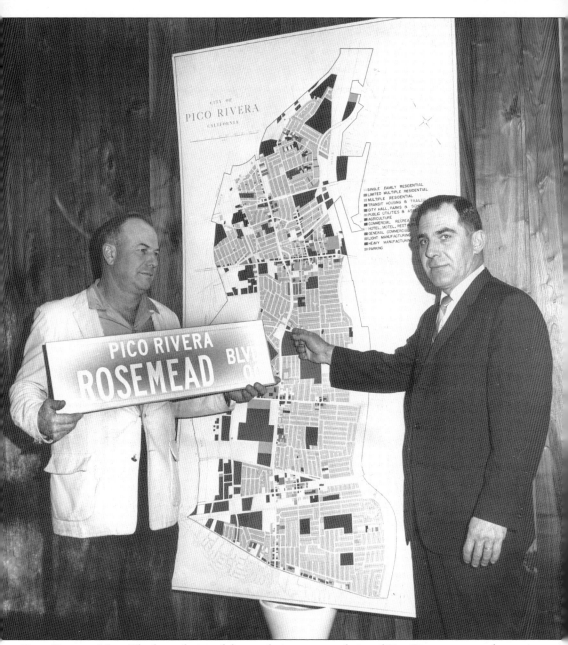

Pico Rivera Map. The boundaries of the newly incorporated city of Pico Rivera are seen here. The city lies between the San Gabriel River on the east and the Rio Hondo on the west and extends north to the Whittier Narrows Dam and south to Telegraph Road. At the time, the area encompassed 7.6 square miles.

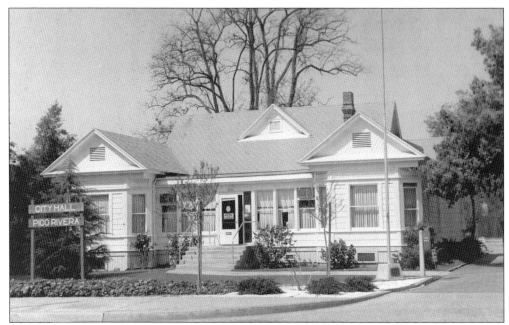

ORIGINAL CITY HALL. Four months after the incorporation, the city purchased the old Gooch Home, located on a 2.7-acre avocado orchard next to El Rancho High School. The 10-room structure was renovated and served as the city hall until May 1963, when it was replaced by a modern city hall built on the same property.

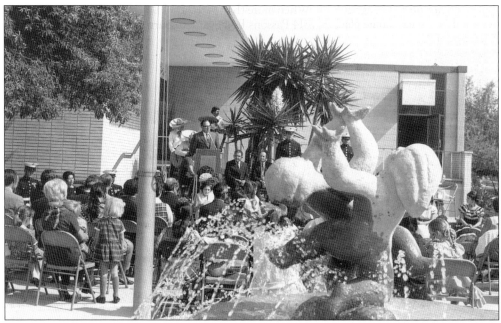

PICO RIVERA CITY HALL DEDICATION, 1963. On June 8, 1963, the completed 12,000-square-foot building at 6615 Passons Boulevard was dedicated during ceremonies marking the city's fifth anniversary. The total cost of constructing the building was over $400,000. The architect was Ray Girvigian, who grew up in Pico Rivera. The sculptor of the fountain was Armando Baeza

OSBURN BURKE. Burke was born in present-day Downey in 1867. During all of his active life, he was identified with Southern California agriculture. He began farming in Rivera, where he raised corn and alfalfa, then grapes. For seven years, he operated the Burke Winery in Rivera, making over 100,000 gallons of wine each year. Even after the urban growth in California, Burke continued his interest in agriculture. When more than 90 years old, he was still planting avocado trees on his 2.5-acre home place at 7814 Passons Boulevard. Osburn Burke passed away in 1960 at the age of 93.

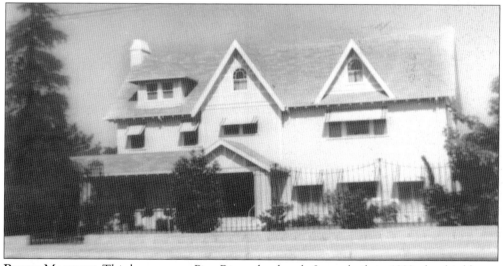

BURKE MANSION. This home was a Pico Rivera landmark. It was built in 1922, the third home to be built on this site by the Burke family. Members of the Pico Rivera History and Heritage Society tried to salvage the 22-room home. The owners, who purchased it after J. Henry Burke passed away, tried to have the mansion donated to the city; however, costs were too high to have it relocated, and the historical landmark met its demise in 1982.

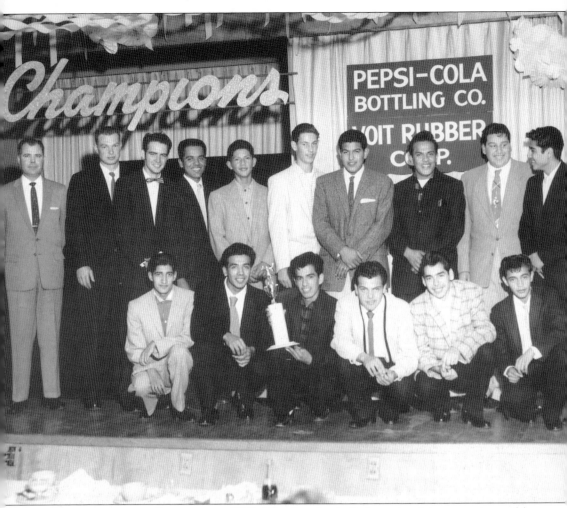

TOURNAMENT OF CHAMPIONS, 1959. The flag football championship team pictured here representing Pico Rivera defeated the Will Rogers Park team. Members include: coach Richard L. Culp, Conrad Fimbres, Dan Rego, Samuel Bueno, Jesse Soto, Hank Ares, Hank Mendoza, John Herrera, Reyes Bueno, Ray Rios, Hank Castro, Pat Rich, Paul Soto, Fernando Torres, Ray Moreno, and Richard Robledo.

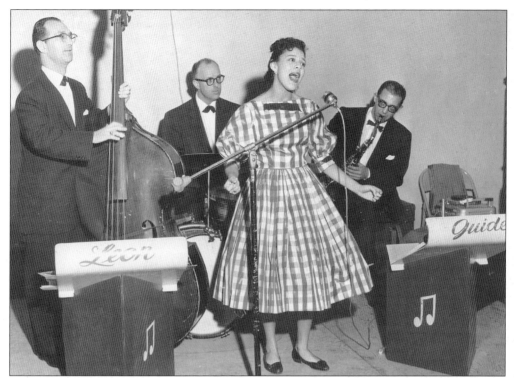

Leon Guide Band. During the 1950s, the Leon Guide Band played music during the many dances held at El Rancho High School. Leon Guide himself is pictured here playing the bass.

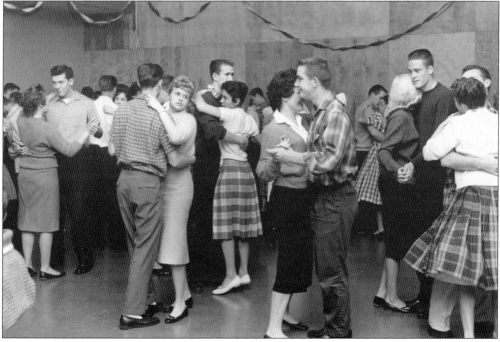

El Rancho High School Dance. One of the many dances at El Rancho High School during the 1950s is depicted here.

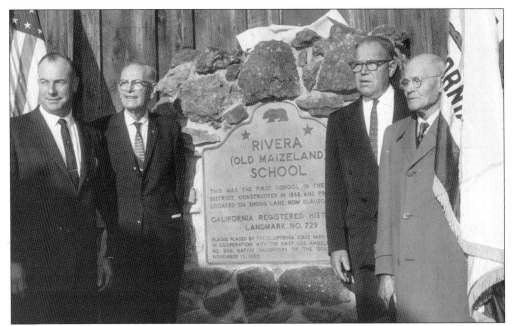

DEDICATION OF RIVERA SCHOOL HOUSE, 1960. The first Rivera School House was dedicated as a state historical landmark at Knott's Berry Farm. Pictured from left to right are Pico Rivera councilman Orlyn Culp; B. V. Brashner, former chamber of commerce president; Frank White, chamber program chairman for the day; and Albert S. MacDonald.

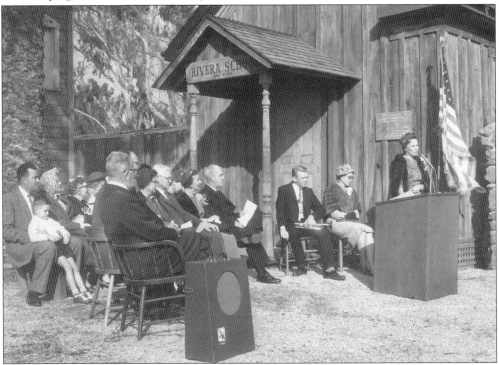

RIVERA SCHOOL. Ruth Benell speaks during the dedication ceremony. The Rivera School remains as part of an attraction at Knott's Berry Farm in Buena Park, California.

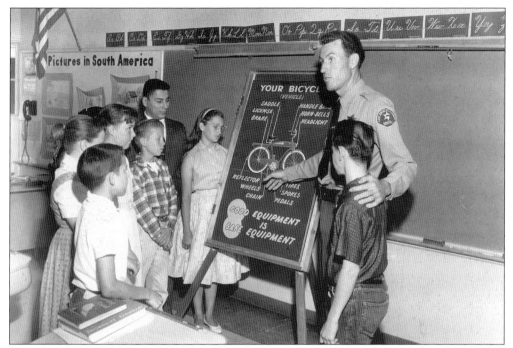

SCHOOL SAFETY. In 1959, the city council initiated the School Safety Education Program. Pictured is Louis R. Diaz, a city council member, along with a Los Angeles County sheriff presenting the school safety program to Pico Rivera students.

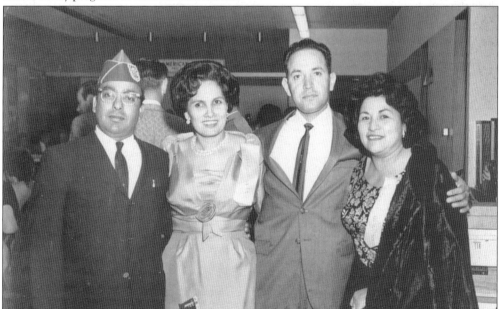

AMERICAN GI FORUM, CALIFORNIA CHAPTER. Pictured is the Queen Coronation Committee. Shown here from left to right are Henry Alonzo, Mary Sanchez, Frank Macias, and Connie Alonzo. The American GI Forum continues to be a beacon of hope and an avenue for involvement not only for the returning veteran, but also for the ordinary citizen aspiring to improve conditions within his own community.

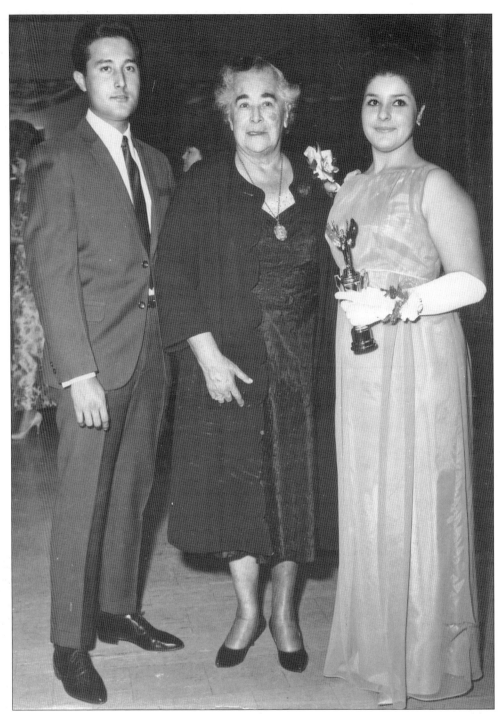

AMERICAN GI FORUM PAGEANT, 1967. The American GI Forum was formed in 1948 to address problems of discrimination and inequalities endured by Hispanic veterans. It would eventually broaden its activities to promote civic affairs. Pictured at one of the pageant events are, from left to right, Henry Perez Jr., Louisa C. Torres, and Sylvia Perez (Rodriguez), who was first runner-up for the 1967 Queen Coronation Pageant.

DANIEL BOONE TELEVISION SERIES, 1967. Elizabeth and Dolores Alonzo (the two girls pictured center, from left to right) were born in Pico Rivera. For many years, they were extras and worked in movies and on television series. This photograph was taken in Agoura Hills while they filmed the *Daniel Boone* television series.

ST. MARIANNE'S SCHOOL. St. Marianne's Parish is located on Passons Boulevard in the Rivera area. It was formed on November 21, 1950. However, the formal dedication of the church was held on March 16, 1952. In 1953, the School Sisters of Notre Dame, St. Louis Province, arrived to begin teaching in the parish school. The school opened on September 15, 1953, with an enrollment of 390 students.

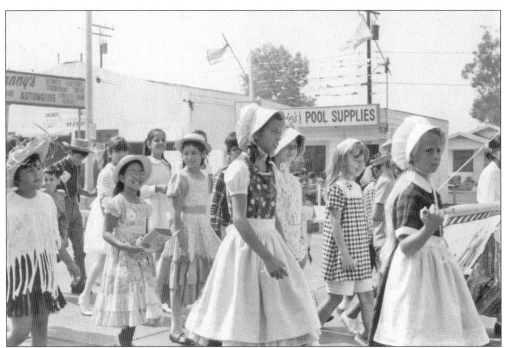

MARCHING KIDS. Along with floats, these kids were a part of the Huck Finn Parade. Here they are seen marching along Washington Boulevard. This parade was discontinued sometime in the 1980s but was reactivated by local leaders in 2005.

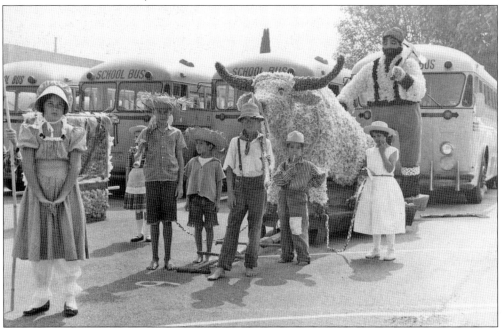

HUCK FINN PARADE. This tradition commenced in 1958 when the city was incorporated. The week of Huck Finn festivities culminated with the traditional and famous Huck Finn Parade. This parade of floats went along Passons Boulevard to Smith Park, where booths provided a carnival atmosphere with prizes for the kids.

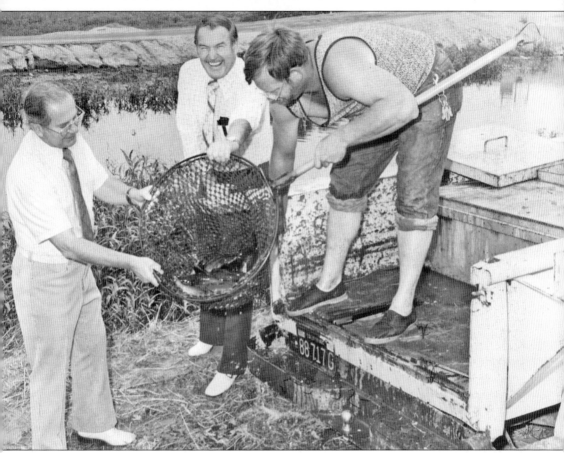

Huck Finn Day Fishing. Pictured from left to right are councilmen Bill Loehr and Garth Gardner and an unidentifed man loading fish in preparation for the fishing day activities for the children. The Huck Finn festivities featured a week of activities for the children of Pico Rivera.

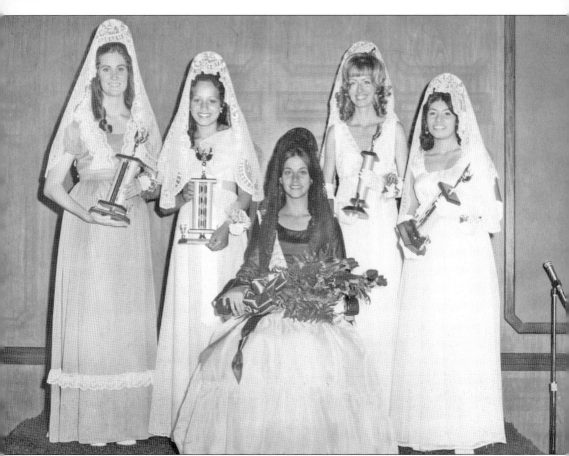

Pico Rivera Queen and Court, 1973. As part of her duties, Queen Donna Tafoya (center) would reign over many civic events throughout the year and would also officiate at the 15th anniversary celebration. Pictured from left to right, the princesses are Jill Tucker, Renee Rodriguez, Antoinette Miller, and Elena Rios.

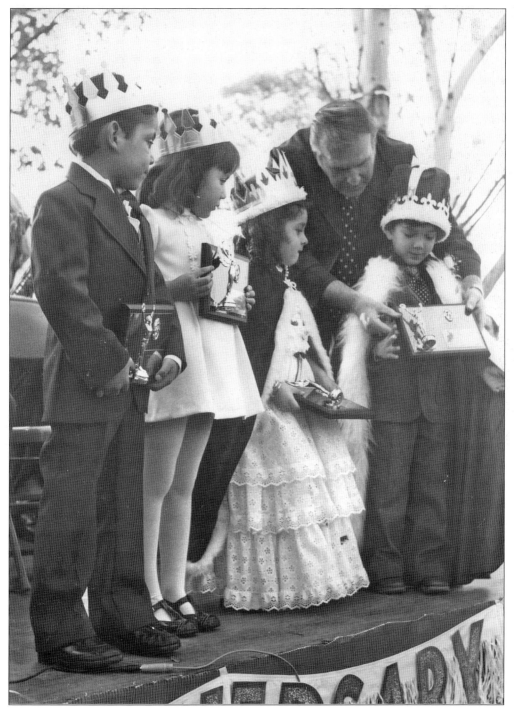

TINY TOT ROYALTY, 1978. During the city's 20th anniversary, a tiny tot court was selected to represent the city. Garth Gardner is handing the awards to the children. Standing from left to right are Prince Cesar Velasquez, Princess Melinda Lopez, Queen Loretta Rodriguez, and King Dominic Martinez.

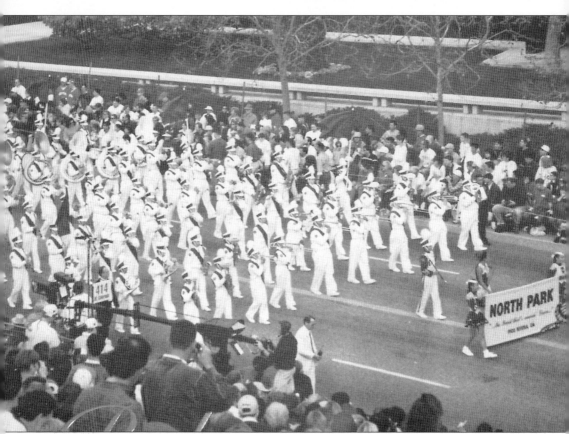

NORTH PARK MIDDLE SCHOOL BAND. The band, under the direction of Ron Wakefield, earned the distinction of being the only middle school band ever invited to play the Tournament of Roses Parade in Pasadena. It was invited to march again in 2005. As well as its previous Rose Parade performance, the band has also performed concerts at New York's famed Carnegie Hall.

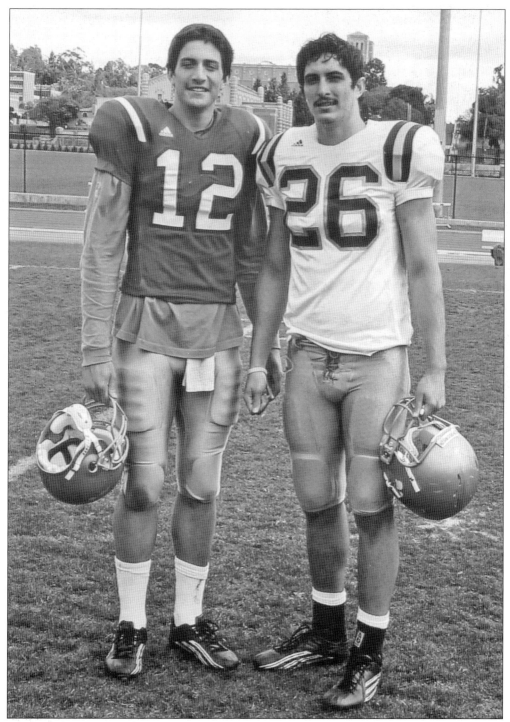

Pat and Joe Cowan. The Cowan brothers live in Pico Rivera. They are one of the rare pass-and-catch combinations in NCAA football. Pat Cowan (left) is the starting quarterback at UCLA, having led them to a major victory over rival USC in 2006. Older brother Joe Cowan (right) is the starting split-end at UCLA as he enters his senior season there in 2007.

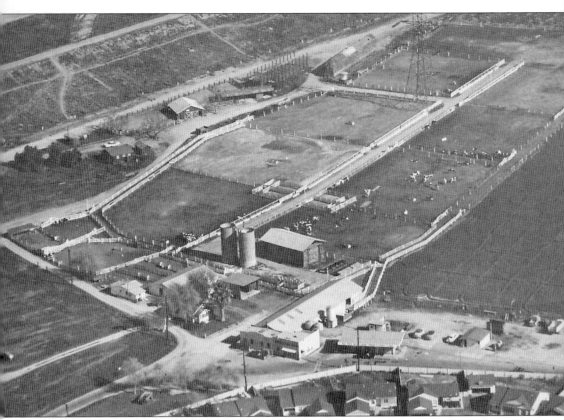

AERIAL SHOT OF KRUSE DAIRY. In 1907, Henry and Anna Kruse settled in Pico after arriving from Germany and operated a small dairy and vegetable farm. In the years following World War II, the Kruse herd and Pico Rivera continued to grow with many tract homes being built in the area. In 1958, the Kruses established a drive-through cash-and-carry dairy store where they sold their dairy products to the surrounding community. The business is now known as Kruse Properties Company. The family recently celebrated its 100th anniversary in the dairy business.

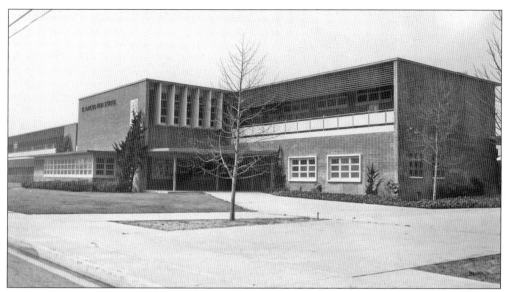

EL RANCHO HIGH SCHOOL, 1952. The school opened its doors in the fall of 1952 with three classes attending and a pupil enrollment of 752. There was no senior class the first year. The first student body selected the name "El Rancho" for their new high school because they felt this name was in keeping with the area's Spanish heritage. In 1956, El Rancho High School received the American Institute of Architects Award as the most beautiful and best architecturally designed high school in the nation.

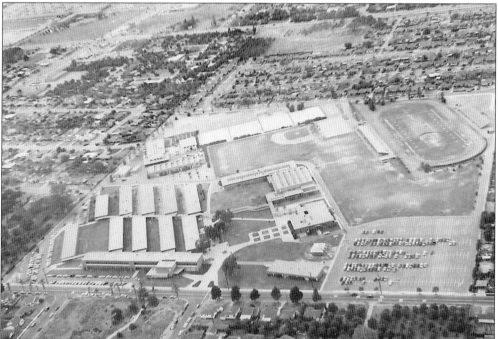

AERIAL VIEW OF EL RANCHO HIGH SCHOOL. The school has gone through several changes throughout the years. Note the extensive orange groves on Washington Boulevard, which is just left of the high school. Also note the open field across the street where Salazar Continuation High School now stands.

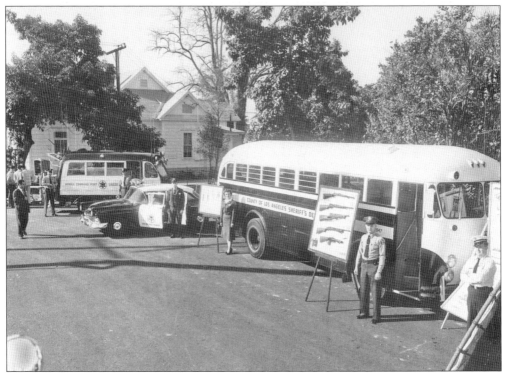

POLICE NEAR CITY HALL. This picture was taken just outside the old city hall south of El Rancho High School. The city of Pico Rivera contracts its police service through the Los Angeles County Sheriff Department. Police protection is the no. 1 expenditure for the city budget every year.

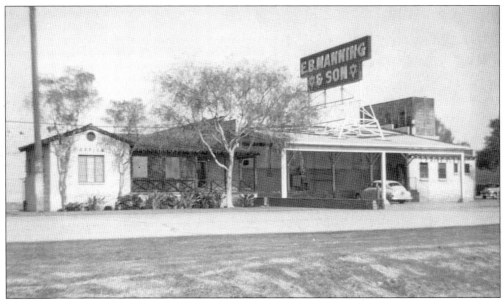

E. B. MANNING AND SONS. This meat-packing company was a pioneer family firm that started in 1910. The company has been commended as a leader in sanitary and humane slaughter methods, and is still in operation today.

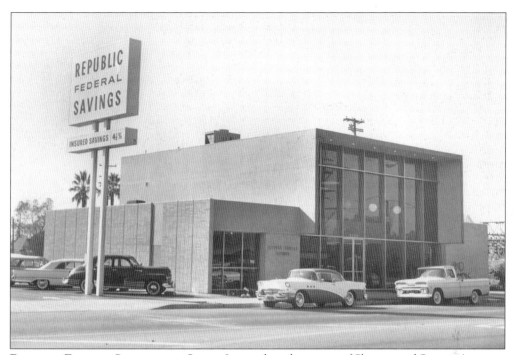

REPUBLIC FEDERAL SAVINGS AND LOAN. Located on the corner of Slauson and Serapis Avenues, the building has changed bank names over the years but has remained a mainstay in the Rivera area for the last half a century.

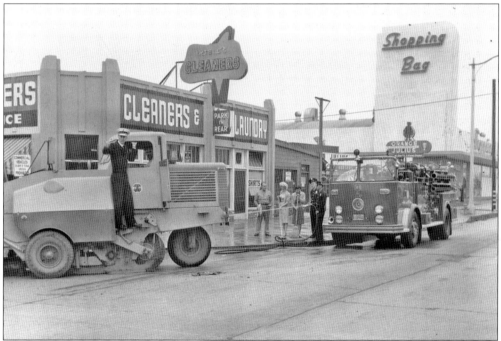

WHITTIER BOULEVARD. This picture was taken just east of Passons Boulevard. Here the fire department is at work. Pico Rivera has their fire service through the Los Angeles County Fire Department. Three fire stations are located in different parts of the city.

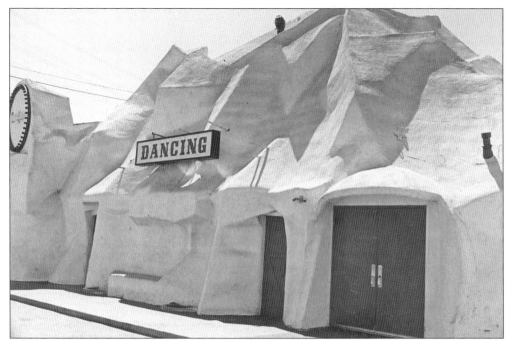

MOUNT BALDY RESTAURANT. The outside of this facility, located on Whittier Boulevard, gave it the appearance of a snow-covered lodge. Inside the building, it looked like a cavern in the snow. In the early 1980s, there was an attempt to restore the restaurant and convert it to a dance hall. This venture proved unsuccessful, and the structure was demolished.

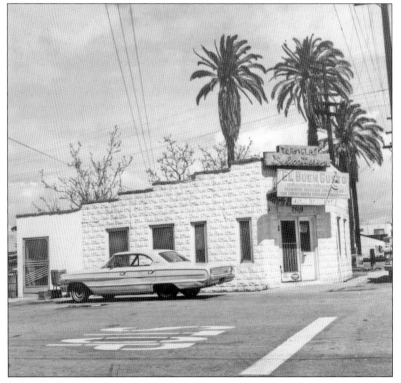

EL BUEN GUSTO DELICATESSEN. This building stood for years in old Rivera. It originally served as a post office. It was destroyed during a fire caused by the collision of Santa Fe freight trains in 1988.

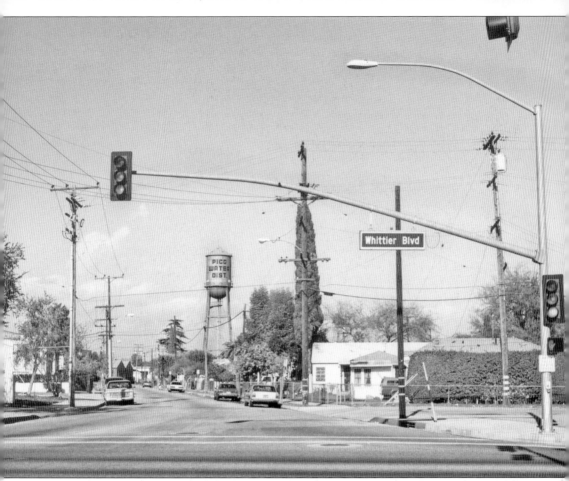

WATER TOWER. This 110-foot water tower stood just north of Whittier Boulevard beginning in 1926. However, given that it had not stored water for some 15 years and also because of safety concerns, it was demolished in 1996. Although the tower was not officially classified as a historical landmark, there were some residents who regarded it as a distinctive feature in the city.

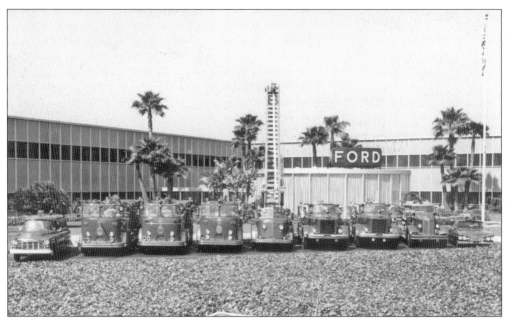

FORD MOTOR COMPANY. The assembly plant at the corner of Washington and Rosemead Boulevards, which opened in 1957, provided employment for upwards of 3,000 people. The plant was eventually closed in 1980. The Northrop Corporation purchased the property in early 1982 and further developed the property for the research and development of the B-2 stealth bomber.

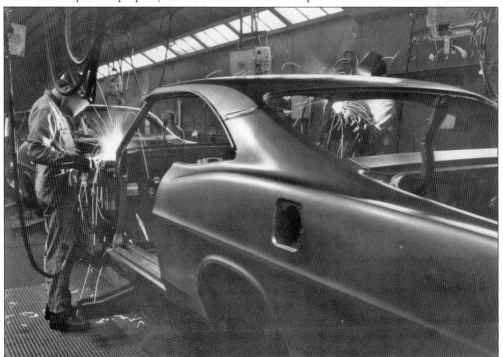

ASSEMBLY LINE. The Ford plant occupied 200 acres and covered 2 million square feet. Around 100,000 Fords and Thunderbirds were assembled in this Pico Rivera branch each year. It was said that 1.4 million cars were produced here in 23 years.

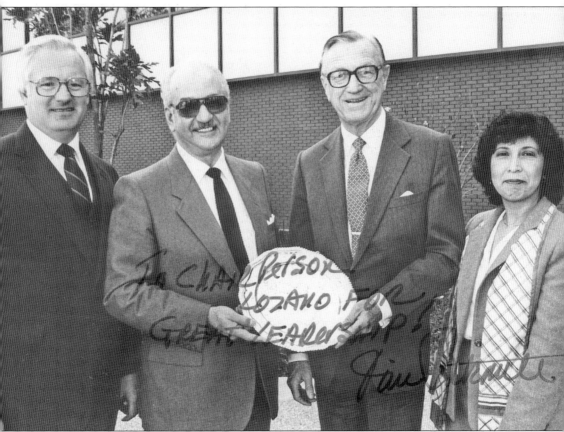

PICO RIVERA BEAUTIFICATION AWARD, 1984. Representatives from the Northrop Corporation received a beautification award. Pictured from left to right are John Patierno, vice president and general manager of the Advanced Systems Division; James Patronite, mayor of Pico Rivera; T. V. Jones, Northrop chairman and chief executive officer; and Susana Lozano, Pico Rivera Beautification Committee chairwoman.

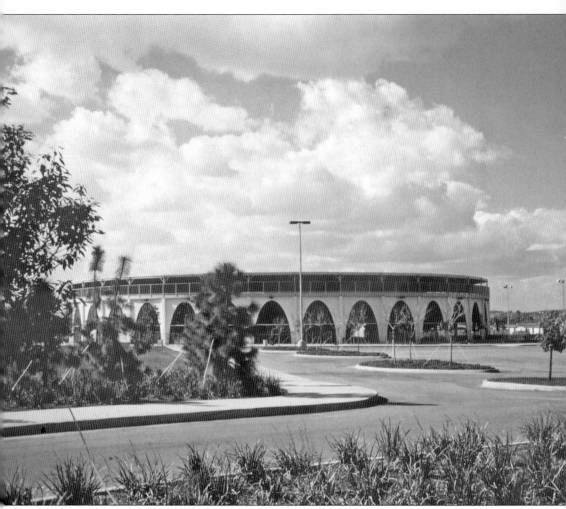

PICO RIVERA SPORTS ARENA. This arena was opened on July 1, 1978, and represented the climax of long-held community expectations for a multi-purpose facility with a stadium concept that would provide a true focal point for the city's identity. Its unique design was made to accommodate charreadas (Mexican rodeos) and other equestrian events.

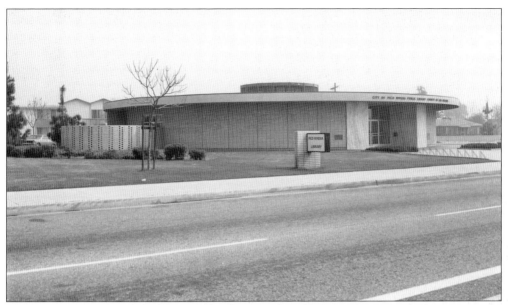

PICO RIVERA LIBRARY. The library officially opened in the 1960s. It is one of a few county-city libraries built with a round architectural design, which holds volumes of books. At this time, there is a proposal to expand and modernize the library site.

THE ETERNAL FLAME. This monument with an eternal flame was dedicated to all veterans past and present. It is located on Mines Avenue just across the street from Smith Park. Veteran's Day celebrations take place at this location by organizations such as the Pico Rivera Veterans Council, which includes the Veterans of Foreign Wars Post Nos. 6315 and 7734 and American Legion Post Nos. 341 and 411.

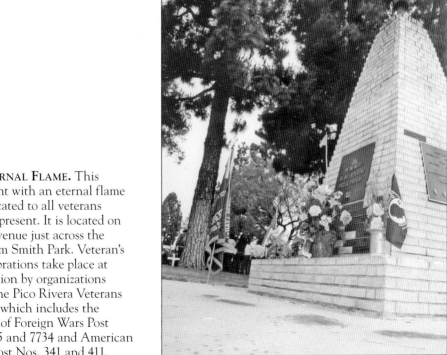

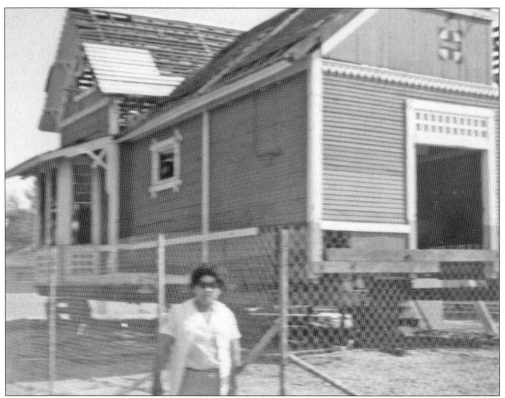

SANTA FE DEPOT RELOCATION. In August 1970, it was learned that the passenger service to San Diego would be terminated from the Santa Fe depot located on Serapis Avenue. The history and heritage society made arrangements to have the structure donated to the City of Pico Rivera.

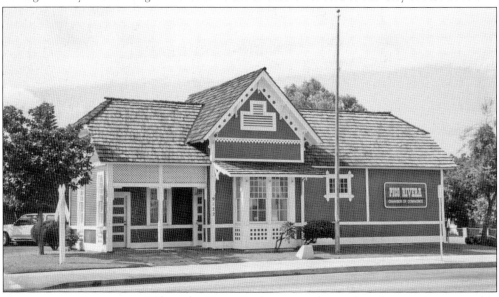

CHAMBER OF COMMERCE. When the Santa Fe depot was donated to the city, it was quickly converted for use by the Pico Rivera Chamber of Commerce. The chamber began operating in this building on February 20, 1974.

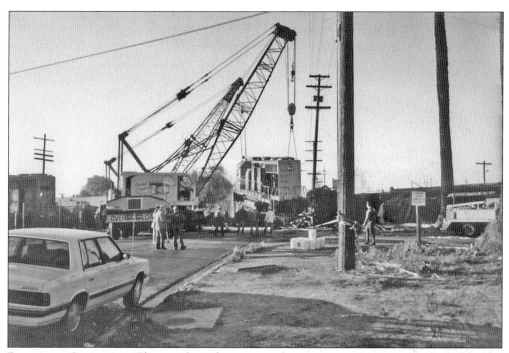

RAILROAD COLLISION. The accident that occurred on January 22, 1988, was caused by the collision of Santa Fe freight trains and destroyed some historical buildings in Pico Rivera. The quick response by emergency crews helped avoid any further damage.

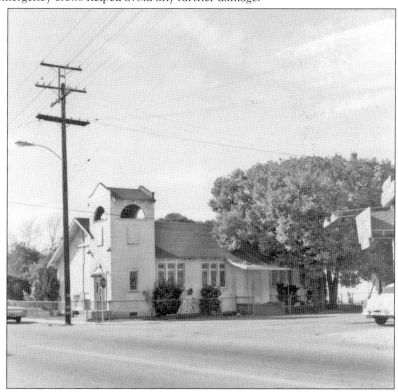

TEMPLE BETHESDA CHURCH. This building served as a worship place for the Temple Bethesda congregation. It was a familiar building to many, as it had stood in the old Rivera business district. It was destroyed by the fire caused by the collision of Santa Fe freight trains in 1988.

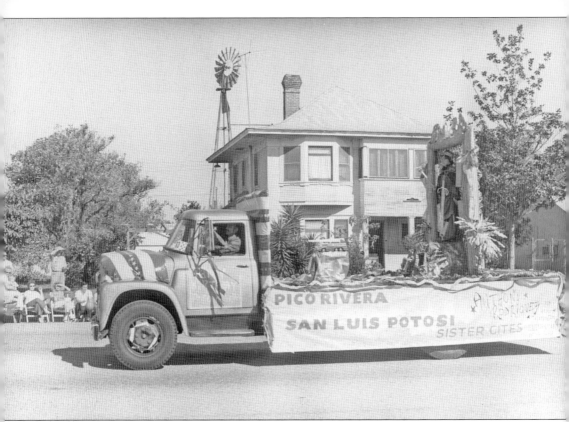

WINDMILL ON MINES AVENUE. During one of the Huck Finn Parades in the early 1970s, a float from Pico Rivera's sister city, San Luis Potosi, Mexico, passes by on Mines Avenue. Of note is the windmill behind the home located at 9239 Mines Avenue. Windmills, pumps, water towers, and other home water systems are a forgotten chapter from the area's history. This home on Mines Avenue had one of the last home water systems, complete with its original windmill. The windmill was taken down some years later.

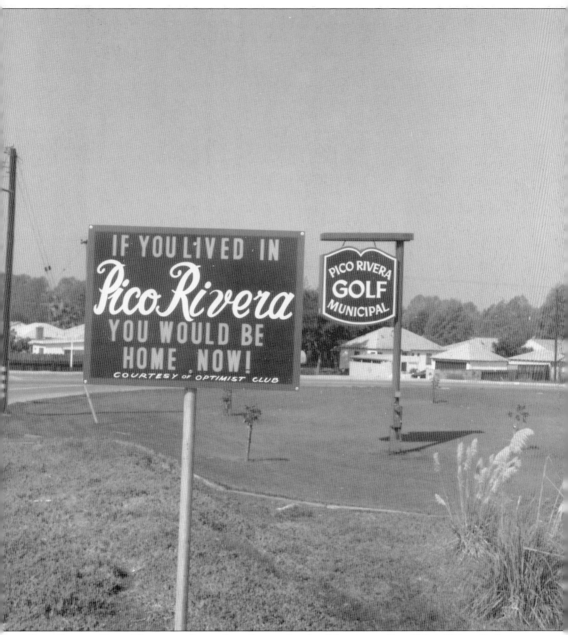

PICO RIVERA SIGN. This sign is located on the north side of the city on San Gabriel River Parkway, adjacent to the nine-hole Pico Rivera Municipal Golf Course. This entry sign campaign with its well-known phrase started in the 1960s. The chamber of commerce aided in the installment of these popular signs, which were a source of pride and joy to residents as they returned home.

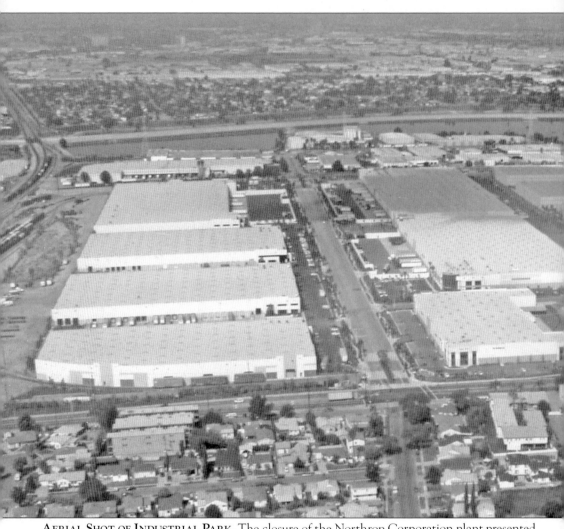

AERIAL SHOT OF INDUSTRIAL PARK. The closure of the Northrop Corporation plant presented the city an opportunity to create something special on the land located just south of Washington

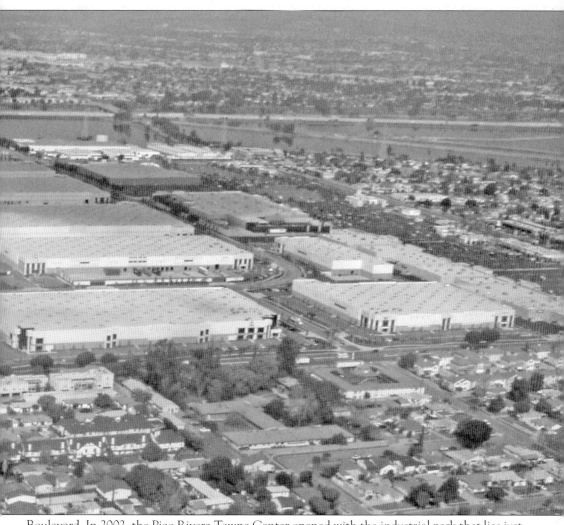
Boulevard. In 2002, the Pico Rivera Towne Center opened with the industrial park that lies just south of it extending down to Rex Road.

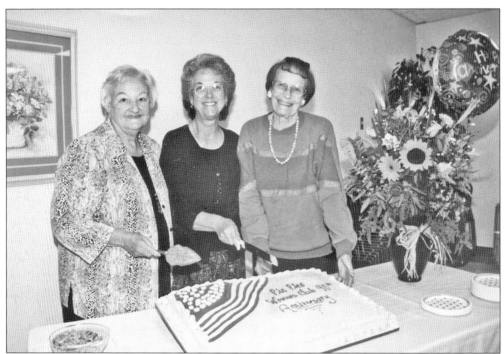

PIO PICO WOMAN'S CLUB. The Pio Pico Woman's Club was founded in 1912. Pictured here in 2002, the club celebrates its 90th anniversary. Pictured from left to right are Cathy McEvers, Alice Mendoza, and Harriett Clement with the anniversary cake.

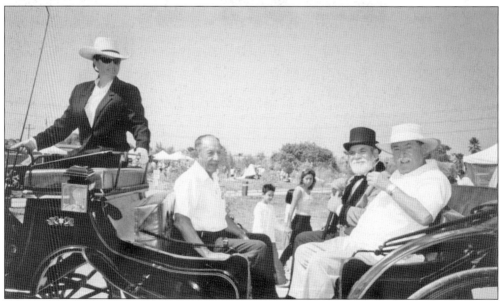

REENACTMENT OF BATTLE OF SAN GABRIEL. The battle of the Californios against the invading American troops led by Col. Stephen Kearney and navy captain Robert Stockton took place in present-day Pico Rivera. This battle was reenacted in 2003. Pictured in the carriage during the festivities are, from left to right, Tom Pico (descendant of Gov. Pio Pico), Roberto Garza (actor portraying Governor Pico), and Councilman E. A. "Pete" Ramirez.

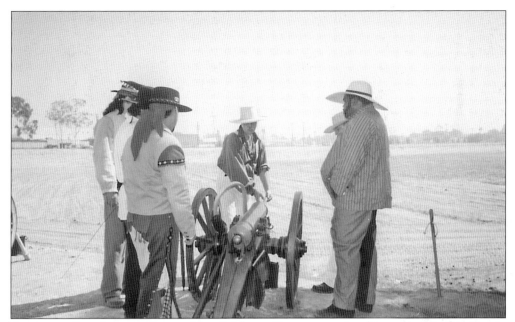

BATTLE OF SAN GABRIEL EVENT. The Californio Days events that occurred at the Rio Hondo Spreading Grounds on September 20–21, 2003, featured reenactments of the famous battle, complete with costumed re-enactors, cannons, musket fire, and horses. Between battles, visitors had the opportunity to explore an authentic 1847 army encampment and see historical displays.

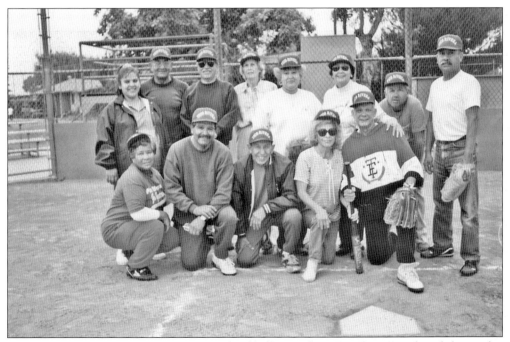

THE GO-GETTERS, 1995. The senior coed softball team from Pico Rivera is, from left to right, (first row) Hilary Urias, Rudy Casas, Tom Pico, Frances Montoya, and Charles Hutchinson; (second row) coach Rosie Garcia, Raul Vega, Jose Martinez, Dorothy ?, Rachel Meister, Connie Solis, Randy Duncan, and Joe Holguin.

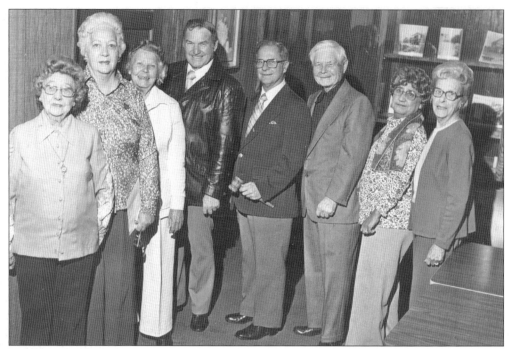

Pico Rivera History and Heritage Society, 1979. Pictured are some of the original members of the society. Shown here from left to right are Hazel Lorig, Emma Woodruff, Martha Russell, Garth Gardner, Bill Loehr, Martin Cole, Rosalie Martinez, and Imogene Johns.

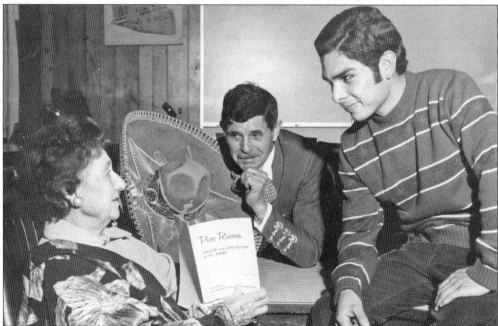

Hazel Lorig. Here holding one of the first publications printed by the historical society is Hazel Lorig (left). She performed many functions for the society, including being involved in festivities for the city, such as the cultural heritage exhibit during the city's 15th anniversary celebration. She was also instrumental in saving and preserving the old Santa Fe depot.

ORGANIZERS OF THE SOCIETY. The three pictured here in the 1970s—William Loehr (left), Hazel Lorig (center), and J. Henry Burke—were largely responsible for launching the Pico Rivera History and Heritage Society. Throughout the years, the society has remained dedicated to preserving the history of the community.

EL CAMINO REAL MISSION BELLS. The mission bells were once a familiar sight in California. In the early 20th century, the bells were spaced along roads marking the approximate King's Highway that extended from Mission San Diego de Alcala in San Diego to Mission San Francisco Solano at Sonoma. At one time, they were a familiar sight on Whittier Boulevard. In Pico Rivera, the development work on Whittier made it necessary to remove two bells. These were preserved and relocated to the Pico Rivera Plaza in 1980.

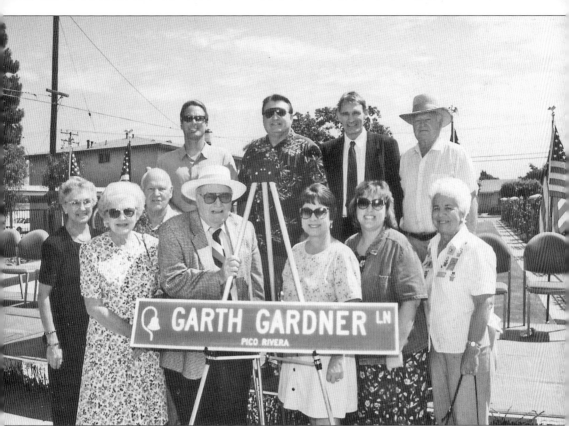

GARTH GARDNER LANE. In 2002, longtime resident and former mayor Garth Gardner received the honor of having a street in Pico Rivera named after him. Pictured during the ceremonies are Mary Bob Gardner, Mary Gardner, Phillip Gardner, former mayor Garth Gardner, Christine Gardner, Kimberly Gardner, Dora Gardner, Robert Gardner, John Gardner, Gregory Gardner, and Aeriel Gardner.

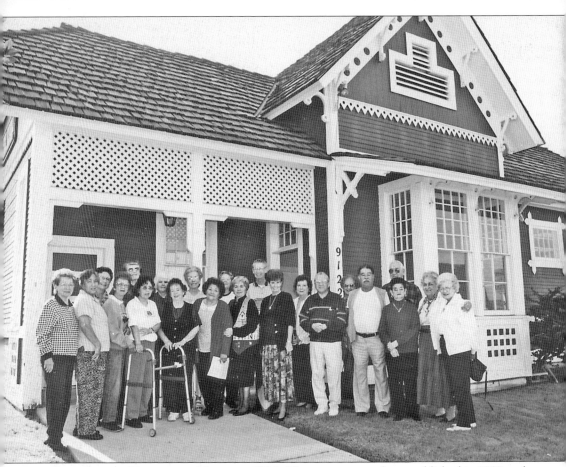

PICO RIVERA HISTORICAL MUSEUM, 1999. The museum was first established in 1992 and was located on Whittier Boulevard. Lenie Medina was the first curator of the museum and was at her post until 2002. The museum was then moved to the old Santa Fe depot on Washington Boulevard. This picture shows the dedication of the museum that took place in August 1999. Posing in front of it are members of the Pico Rivera History and Heritage Society.

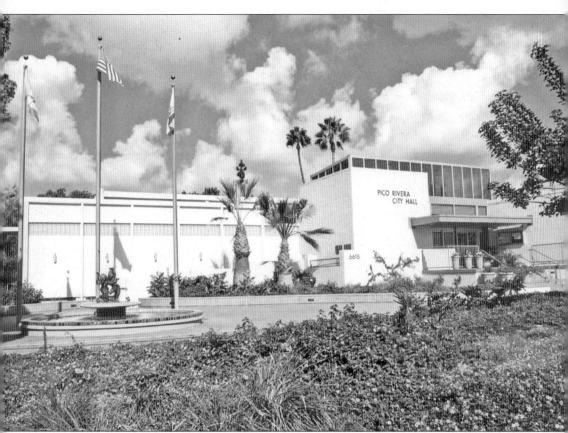

CITY HALL OF PICO RIVERA. The city is a close-knit community of 66,000 residents. While the city is only nine square miles in area, it includes 10 neighborhood parks, an Olympic-size swimming pool, a golf course, a skateboard park, and a senior center, as well as an acclaimed Centre for the Arts. Construction has also begun on a 14-screen cinema complex. The city will be celebrating its 50th anniversary in 2008. Its hometown feel and family spirit will continue to grow for many years to come.

Across America, People are Discovering Something Wonderful. Their Heritage.

Arcadia Publishing is the leading local history publisher in the United States. With more than 4,000 titles in print and hundreds of new titles released every year, Arcadia has extensive specialized experience chronicling the history of communities and celebrating America's hidden stories, bringing to life the people, places, and events from the past. To discover the history of other communities across the nation, please visit:

www.arcadiapublishing.com

Customized search tools allow you to find regional history books about the town where you grew up, the cities where your friends and family live, the town where your parents met, or even that retirement spot you've been dreaming about.